NOAH BAUMBACH

Marriage Story

ASSOULINE

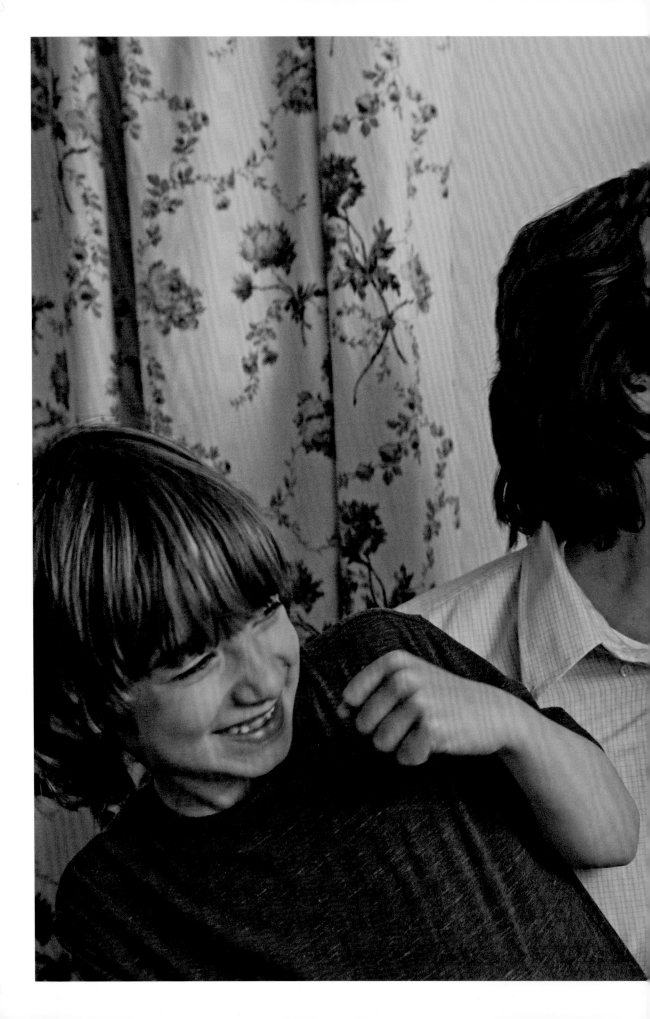

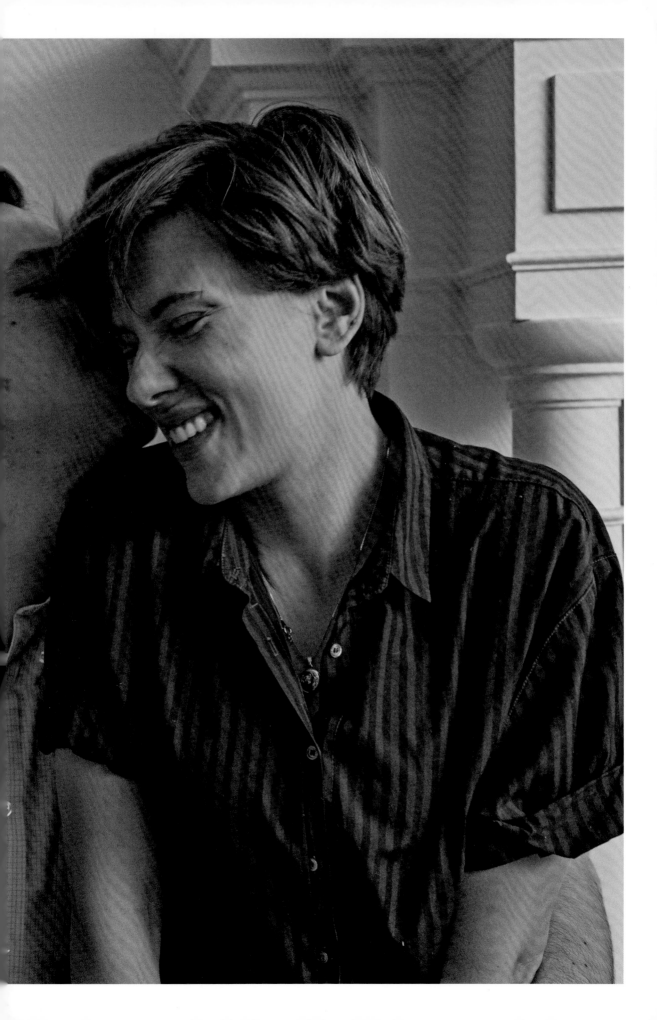

Introduction

BY LINN ULLMANN

Translated from the Norwegian by Thilo Reinhard

I

I've always loved the opening of Marguerite Duras's novel *The Lover,* in which the aging narrator describes her own face: "I often think of the image only I can see now, and of which I've never spoken." The story she is about to tell is already recorded on her face, and the first pages seem to me like an infinitely long close-up. After watching Noah Baumbach's remarkable *Marriage Story*, I started re-reading *The Lover*. The film and the novel tell two completely different stories, yet both are startling meditations on what a human face can reveal if you look at it long enough. By letting the camera rest on Nicole (Scarlett Johansson) and Charlie (Adam Driver), Baumbach tells the story of two people who once loved each other very much—all the little moments that accumulate and make up a marriage—moments of friendship, deception, desire, disappointment, anxiety, unexpected day-to-day happiness, rage, gratitude, tenderness, hostility, recognition. At times, Nicole and Charlie's faces practically melt into each other; at others, the distance between them seems infinite.

II

I keep thinking about impossible math puzzles—the ones no one can solve, that have never been solved, the puzzles that geniuses have spent their lives trying to figure out— like the P *versus* NP problem. A marriage, if you look at the math, is a similarly impossible puzzle: How can you be two and one at the same time? And then there are children, and you're three or four or five people. In this case, Nicole and Charlie's eight-year-old son, Henry. His parents try, fail and try again, like we all do; they are good parents, good people—we don't doubt it. This is one of those rare grown-up films, where grown-up complications are tenderly and forgivingly depicted—and where everything remains complicated. When I see Baumbach's films, I'm sometimes reminded of utterances ending in mid-sentence. Someone once told me that writing a good novel (and the same goes for making a good film) is having the courage not to insist on having the last word.

III

There are no heroes, and no villains. Not even the three lawyers (recalling the three witches in *Macbeth*), who make an even greater mess of an already messy situation, are villains. Everyone's just doing their best.

The unraveling of a marriage has its own internal and relentless logic. I want to call out to Nicole and Charlie: *People, you can fix this, don't give up!* But the collapse is imminent, never mind how gently it unfolds. Divorce is a human calamity that none of us have the slightest idea how to deal with. There are no adequate social customs or rituals to resort to. What we're left with is loss. Unspeakable loss. No one sends flowers; no one offers their condolences. It's all terribly embarrassing. And shameful. And heartbreaking. And scary. No one is dead, exactly; but everything is broken. Everything is torn apart, split in half. What was shared will now be divided. Except you can't divide a child. The math doesn't add up.

IV

It's no coincidence that our lead characters work in theater and in film. Marriage and divorce are very specific kinds of performances. They play out in private and public arenas, in living rooms and courtrooms. In his similarly titled novel *Story of a Marriage*, Norwegian author Geir Gulliksen writes: "I lived my whole life before that pale face"; as if the spouse's face were a screen or a stage. Nicole and Charlie live in each other's faces—*my life reflected in your face and your life reflected in mine*—until the catastrophe, the unraveling, ensues almost imperceptibly. And when that happens, everyone else enters the stage to examine the shards.

There are many lovely scenes. Here is one: We see Charlie, his son and a female evaluator assigned to observe them. There's a glass of water, a dinner table, a knife. There's the haunted face of the evaluator. Baumbach is a master at mixing genres (comedy, tragedy, silent film, thriller, musical) and depicting human awkwardness. Yes, this is how we are—shy, clumsy, uncomfortable, sad—and it becomes especially noticeable when we're being looked at, when our private moments become acts of performance. A father performs the role of the father, an evaluator performs the role of the evaluator—and then there's the child, who doesn't want to perform at all. It's hilarious and painful. The film tells the story of what our bodies and faces look like when we're trying to act naturally while at the same time feeling completely lost, like a dance choreographed by Pina Bausch.

V

What is a divorce? Wisely, the film offers no definitive answer to why this specific couple is breaking up. Answers to that question accumulate and shift. We are our stories, and for Nicole and Charlie, all the stories have been smashed to bits. Look at all the pieces.

"I show people who move and speak . . . that is my true subject," said the French filmmaker Éric Rohmer. The same can be said about Baumbach, and this unforgettable film about love and loss—and the stories we tell.

Charlie

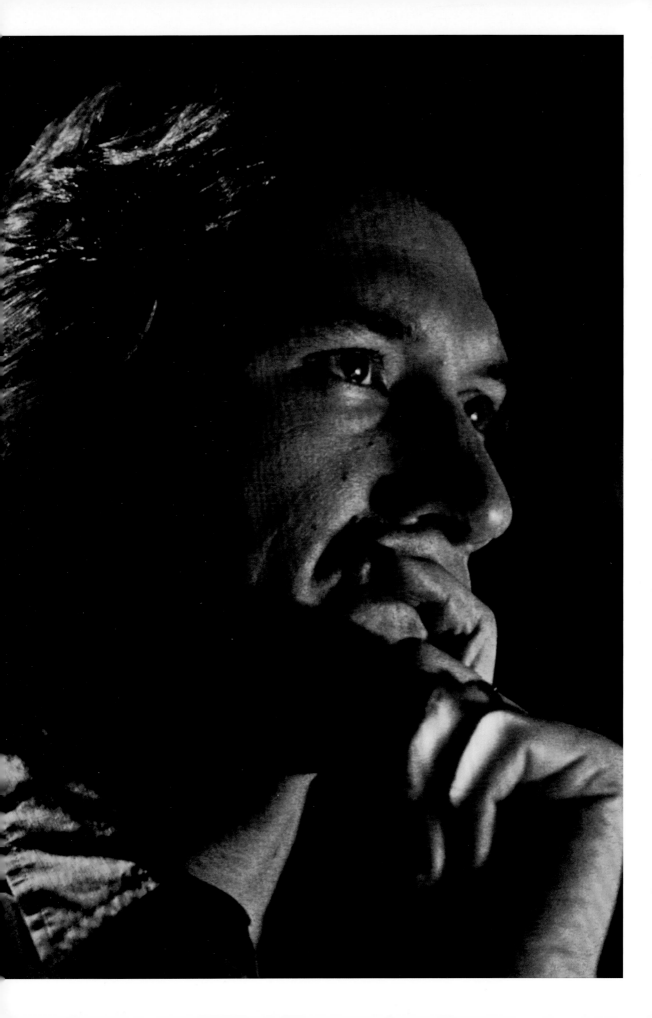

"Marriage, of course, also continues in divorce—you're married the whole time you're doing it. And when a kid is involved, marriage continues, in a sense, after the divorce as well."

NOAH BAUMBACH

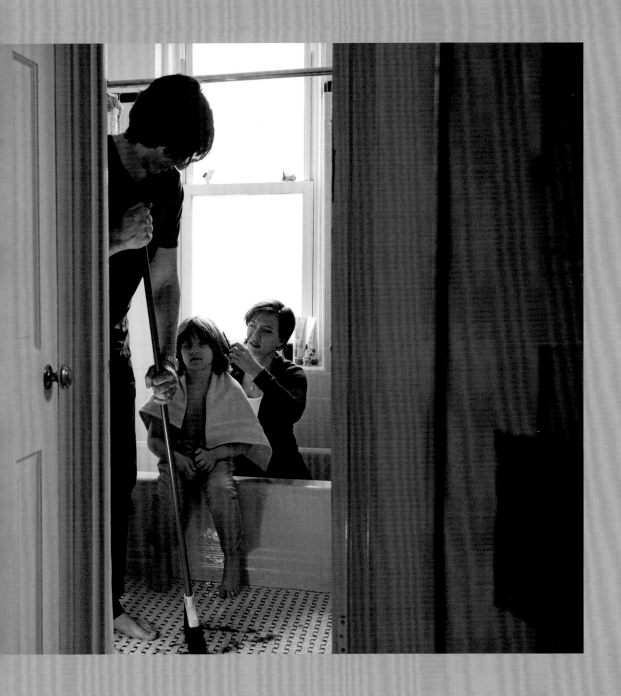

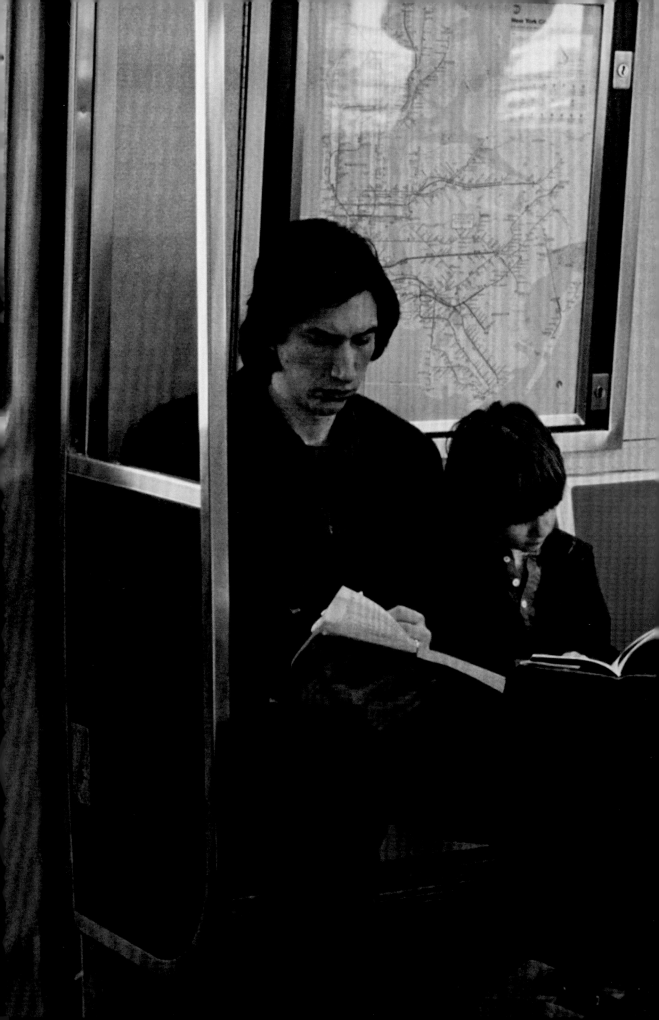

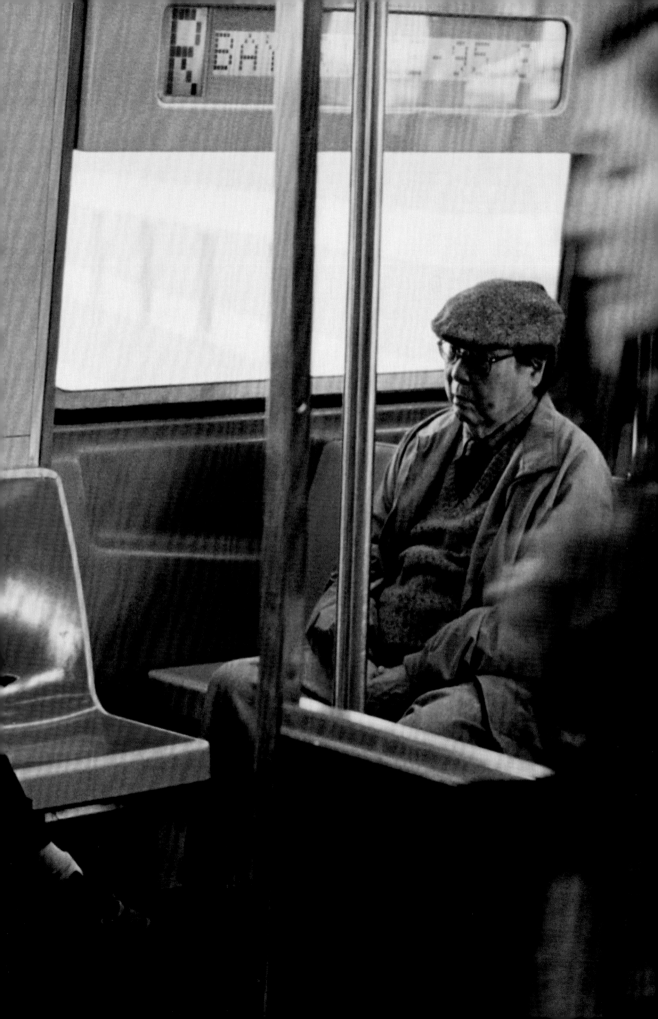

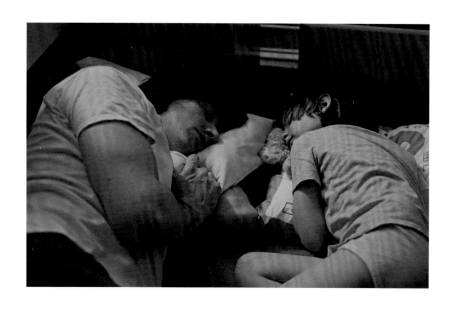

NICOLE (V.O.)
He loves being a dad, he loves all the
things you're supposed to hate, like the
tantrums, the waking up at night.

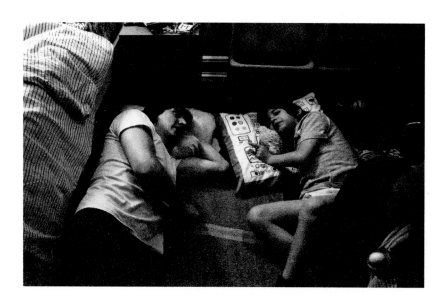

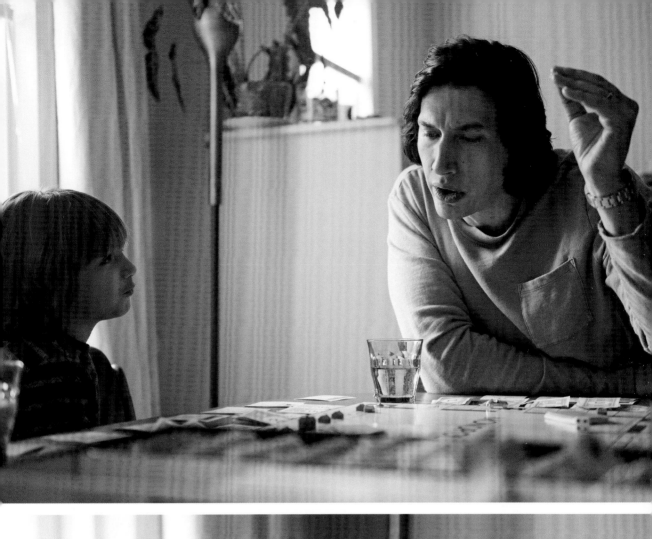
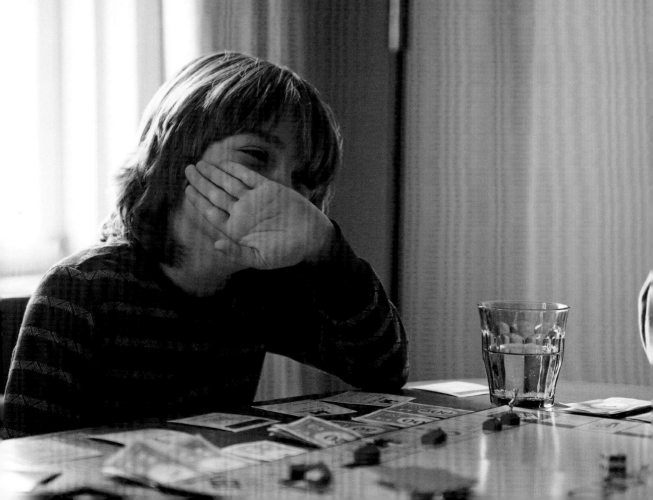

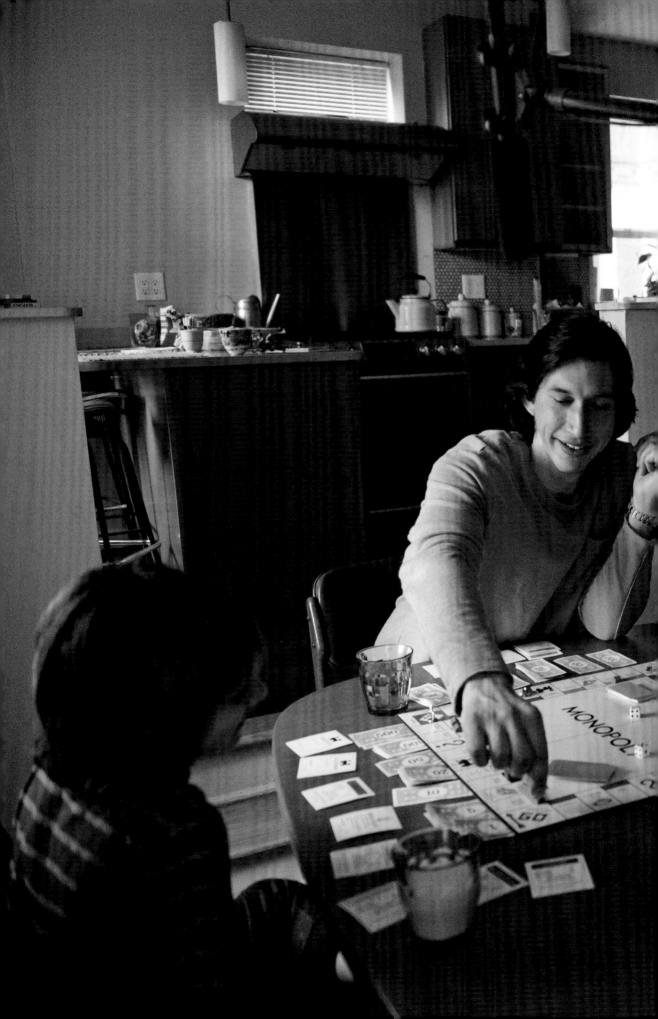

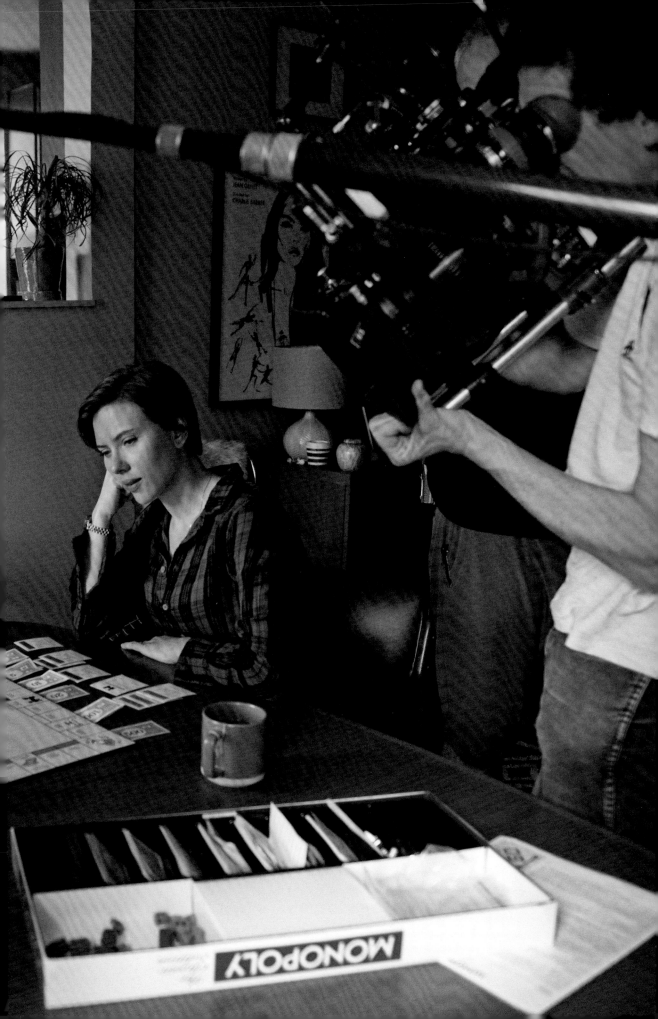

"This movie is so much about different forms of performance."

JENNIFER LAME, EDITOR

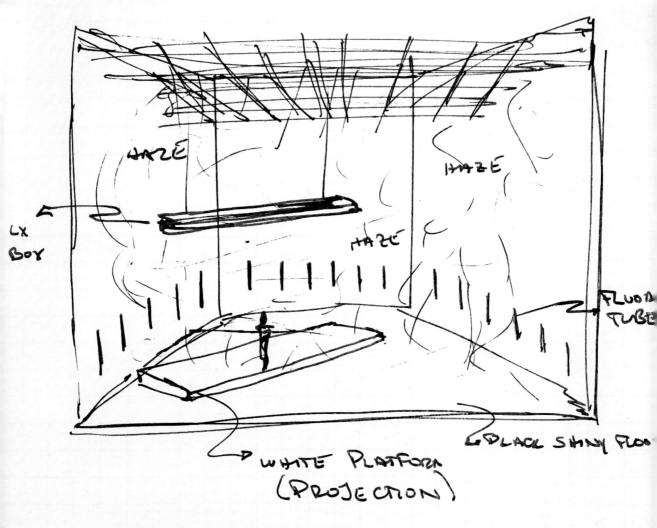

HAZE

HAZE

HAZE

LX
BOX

FLUOR
TUBE

WHITE PLATFORM
(PROJECTION)

└ BLACK SHINY FLOOR

* DRAW EYE UP for transition

+ goes from very personal moment
 of closeup + reflected in projection

+ to stark, open, exposed vulnerable
 raw space

"We basically conceived an entire theatrical production that you're only going to see for 30 seconds. But it has to work as a piece and as a concept."

NOAH BAUMBACH

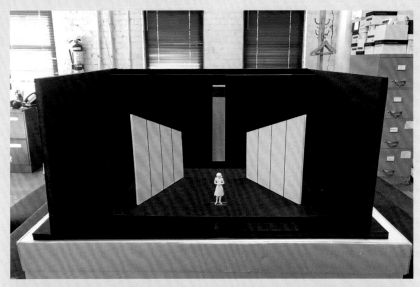

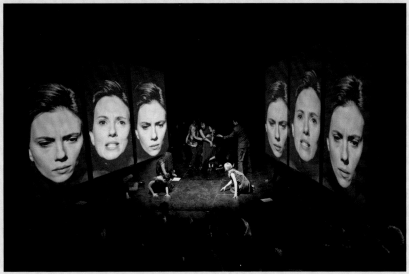

"Charlie is a very principled person. He kind of prides himself to follow the lineage of the Joe Papps of the world and the John Cassaveteses—very scrappy, independent."

ADAM DRIVER

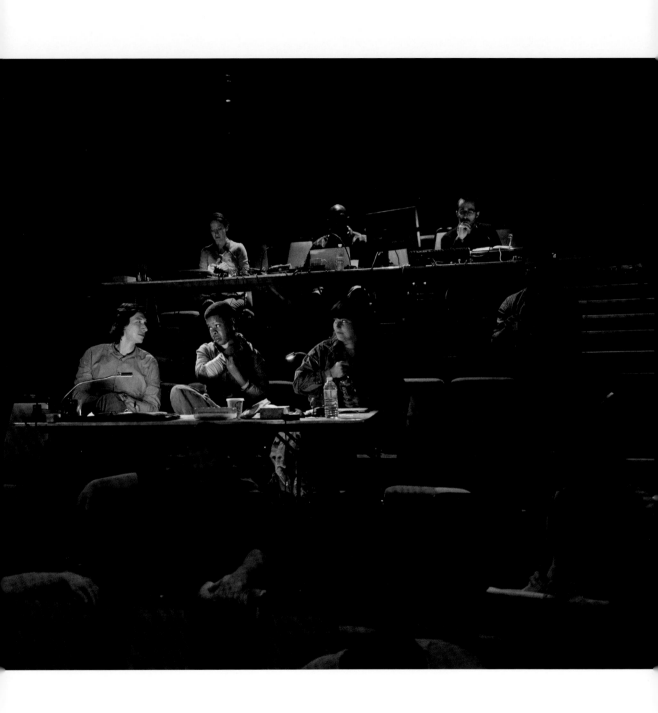

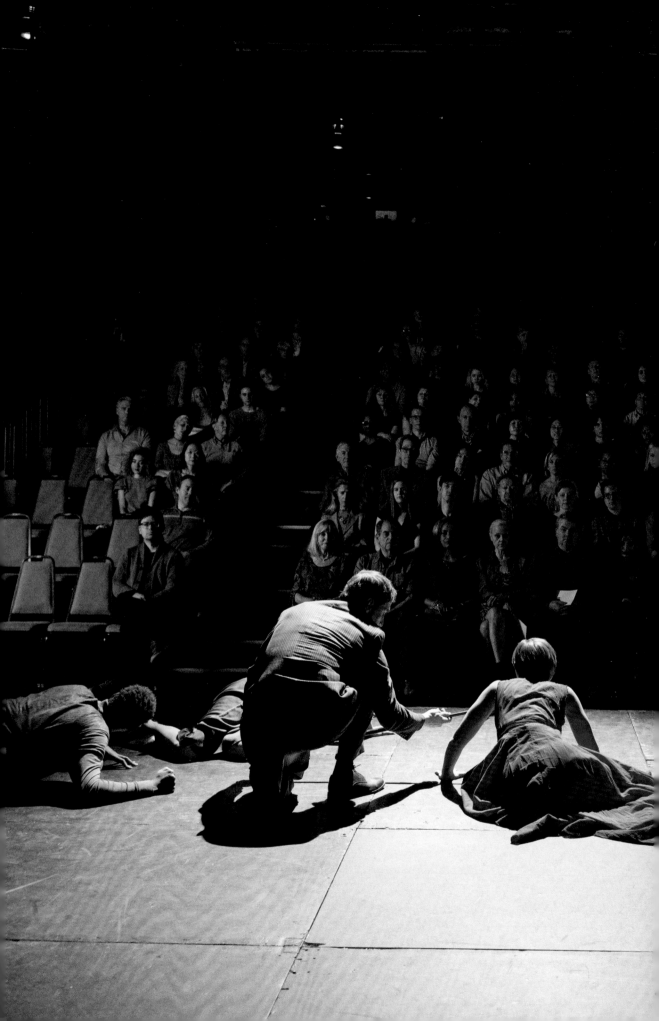

"I thought of the theater company as a Greek chorus. A theme of the movie is family, and that's another family. They remain a kind of family for Charlie there at the end. Charlie loses Sandra and Cassie in a way, and Nicole loses the theater family."

NOAH BAUMBACH

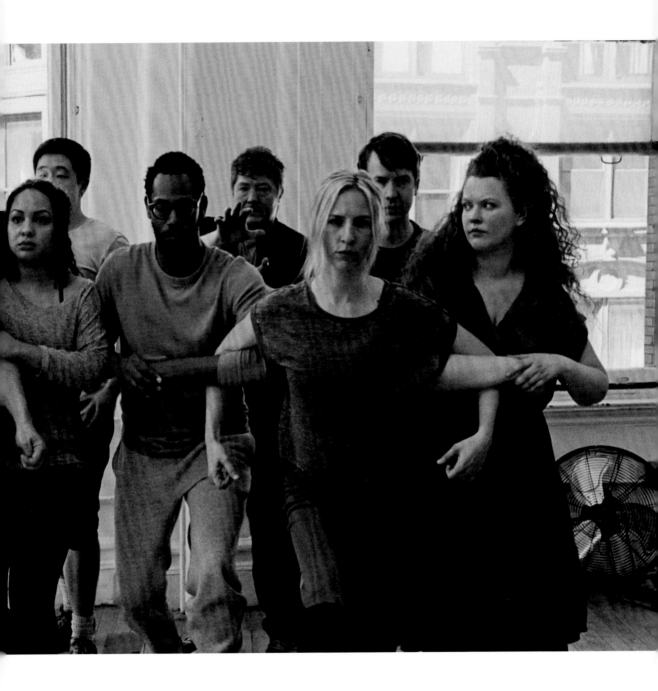

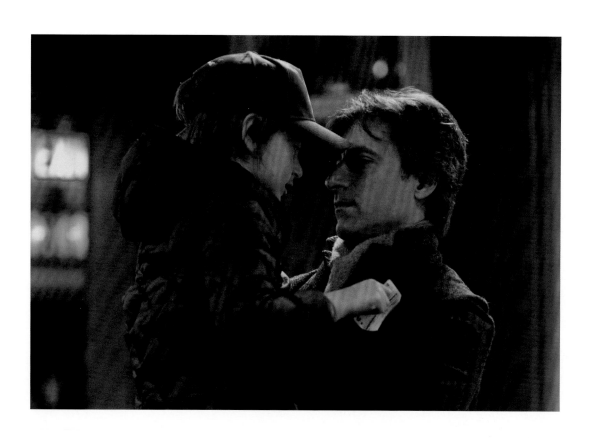

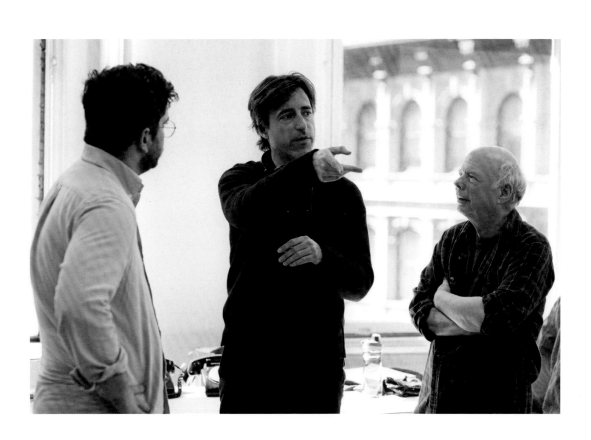

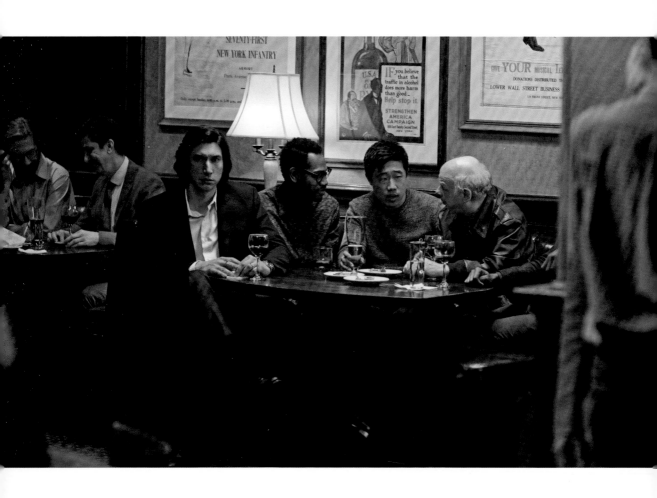

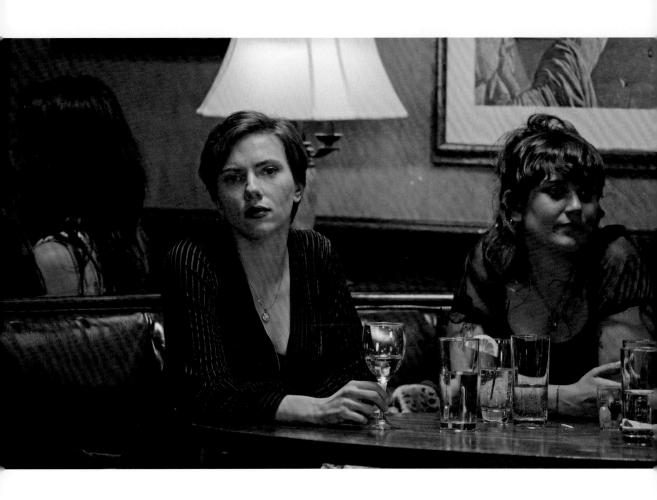

"One of the first images of the movie is over Nicole rising from out of the subway. It's an image I've always wanted to put in a movie; it's so New York. It's like you're coming out of the earth." NOAH BAUMBACH

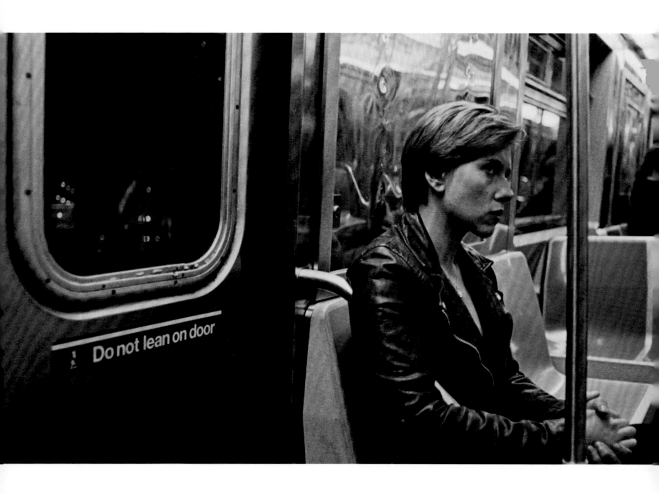

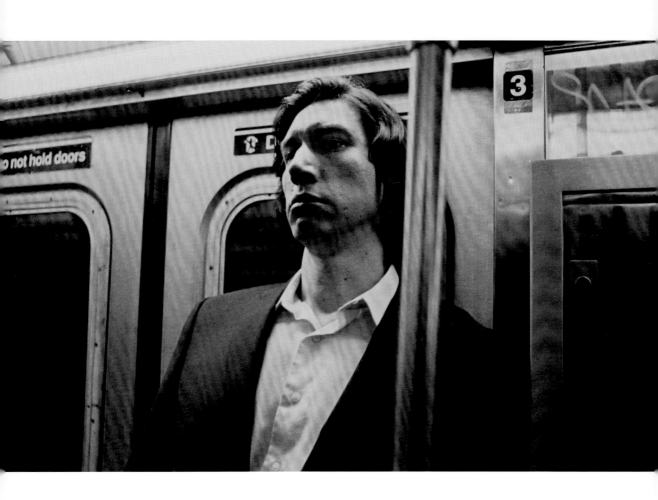

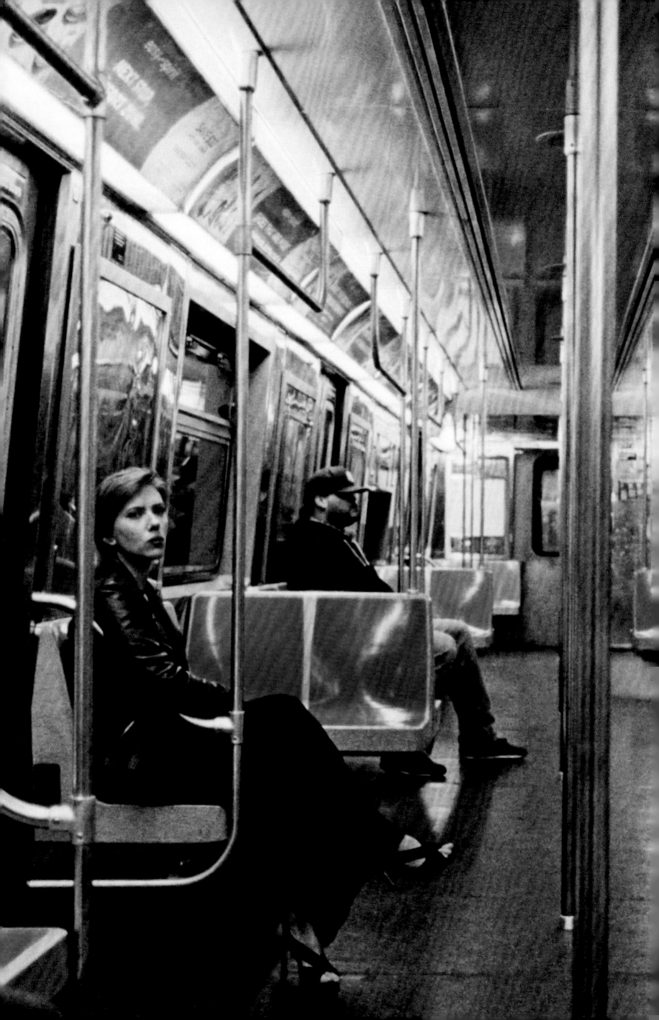

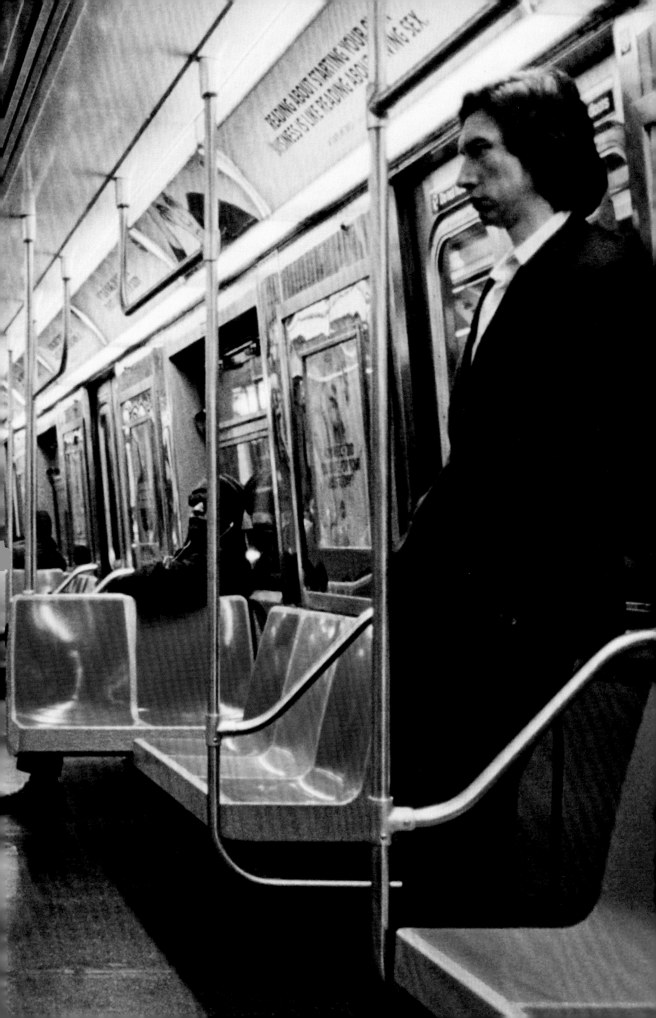

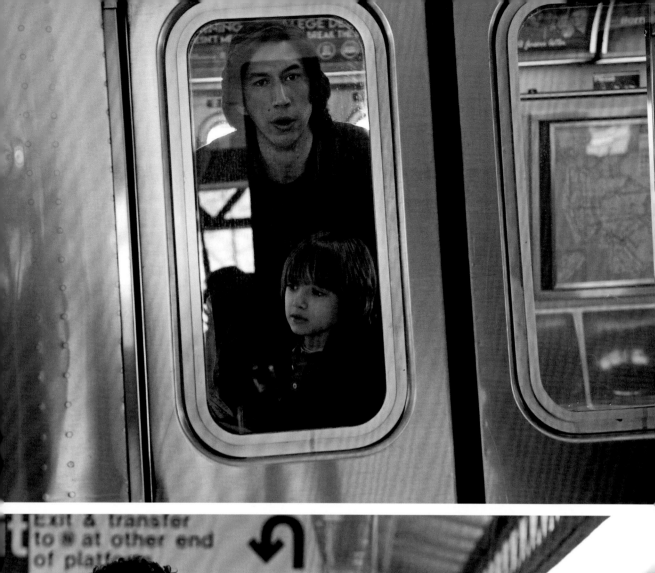

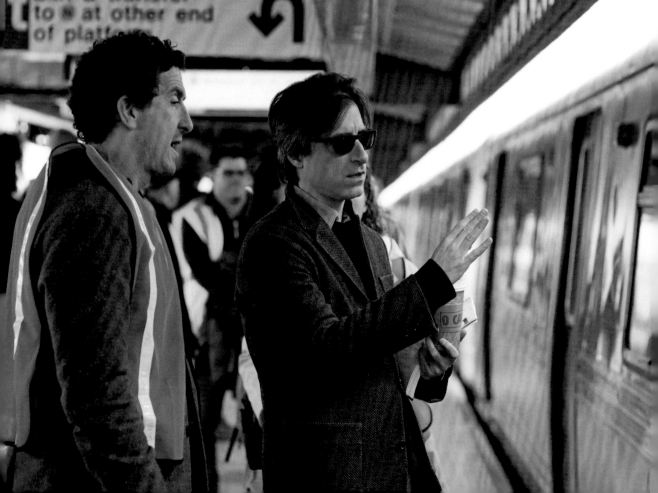

CHARLIE
... we're a New York family.

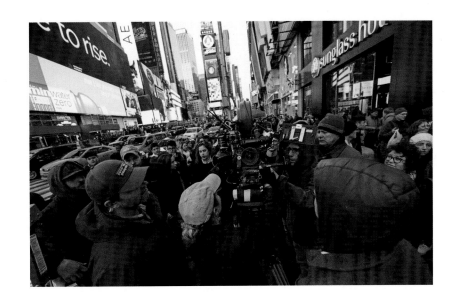

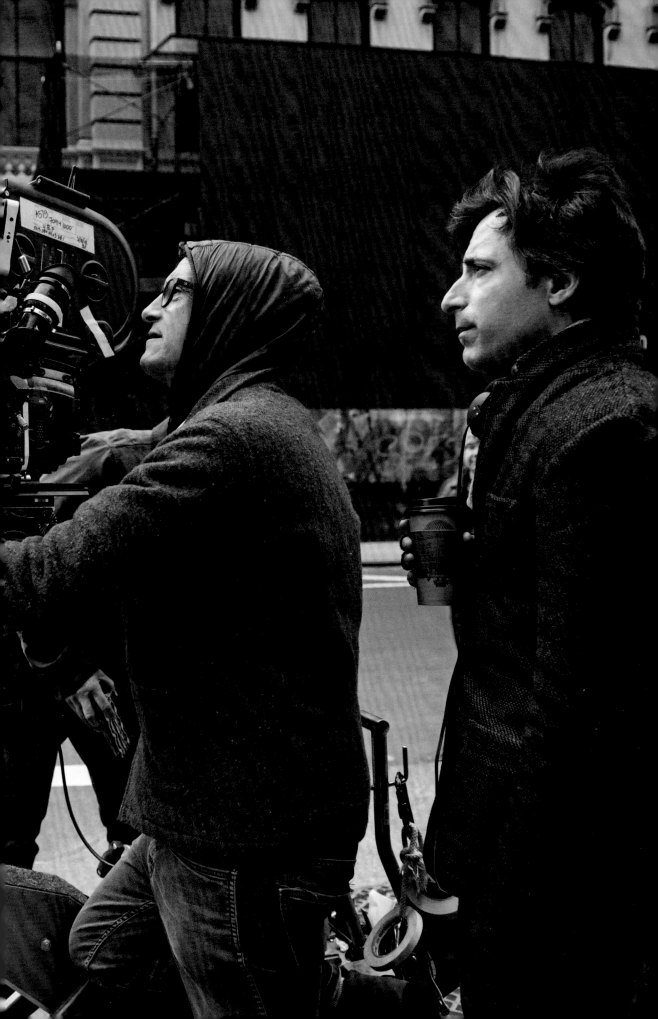

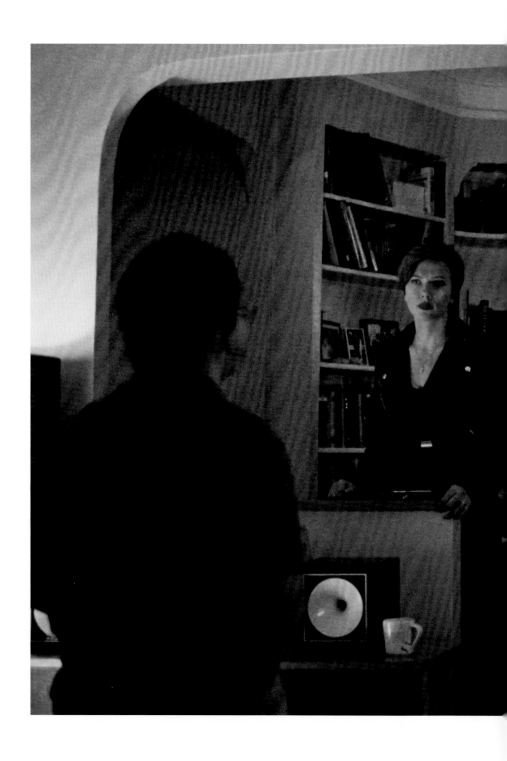

"One of the things Jade, Robbie and I liked about their apartment when we scouted it was the proscenium. There's a step up—it looks like a stage. Nicole's house in LA has the same arched ceilings. The kitchen at Sandra's has many

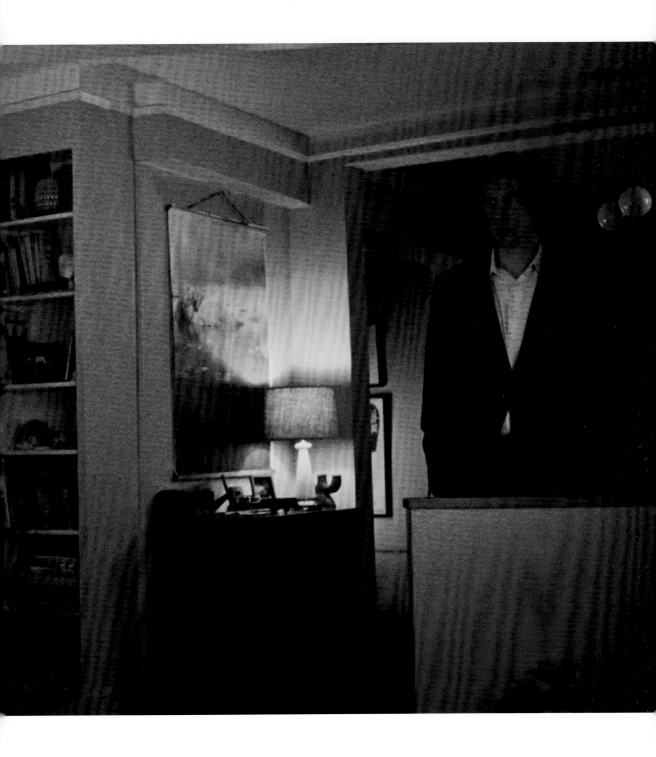

entries and exits. It's as if there's an onstage and offstage.
We looked for these things, not just for symbolic meaning,
but because they're compelling to shoot." NOAH BAUMBACH

BERT
I see no reason--you both love your son, you respect each other--

why this shouldn't be relatively pain-free?

"Noah comes over, and I play piano while we look at the movie, much like the silent movie days. It's very different from most directors. It's a real pleasure working with him."

RANDY NEWMAN, COMPOSER

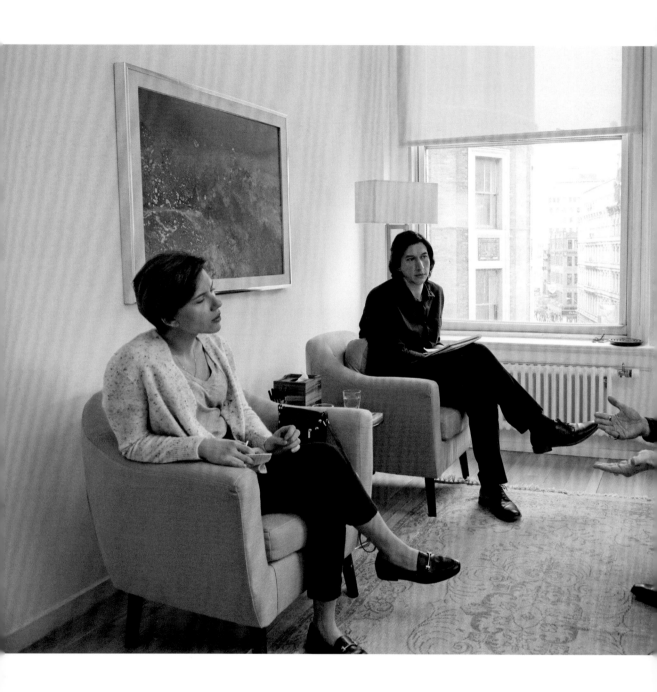

"We didn't want to shy away from white—the blank slate of white walls and what white meant in the story. For Noah, it's really important to keep things grounded in reality."

JADE HEALY, PRODUCTION DESIGNER

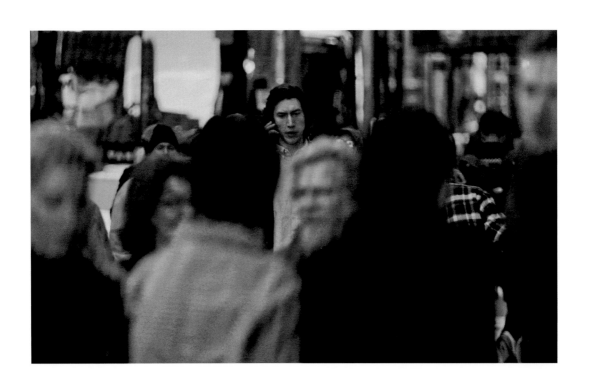

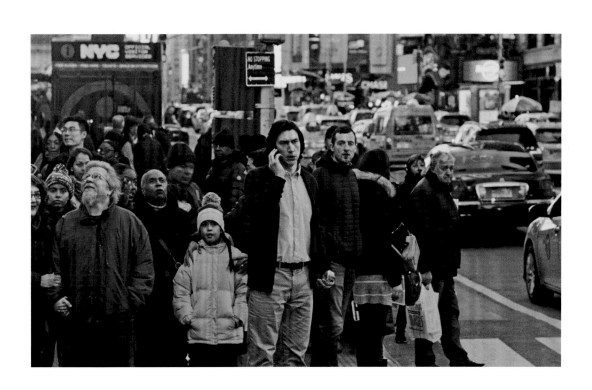

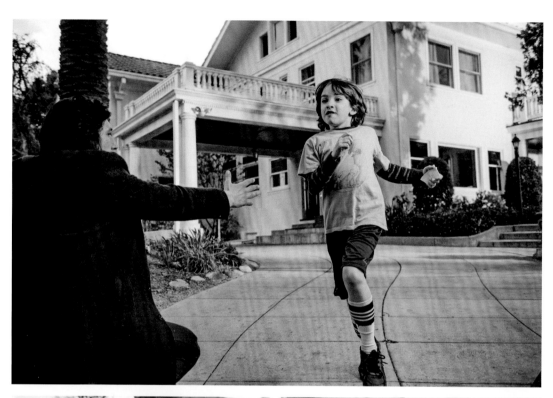

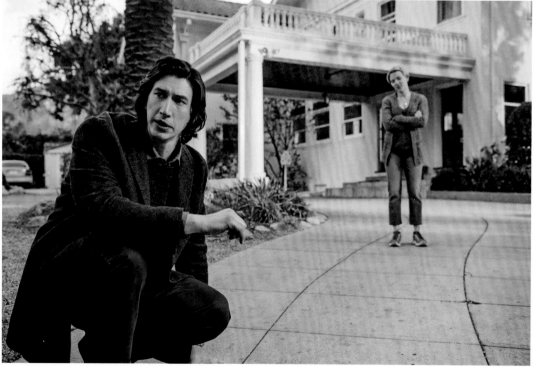

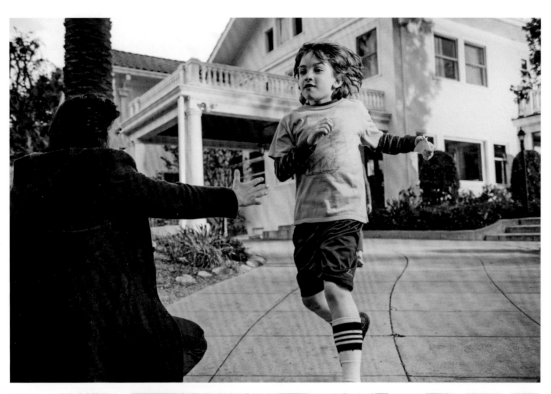

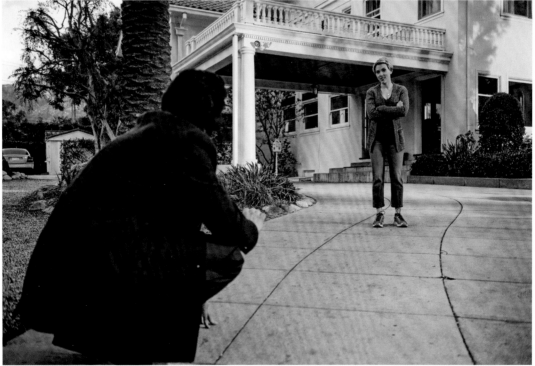

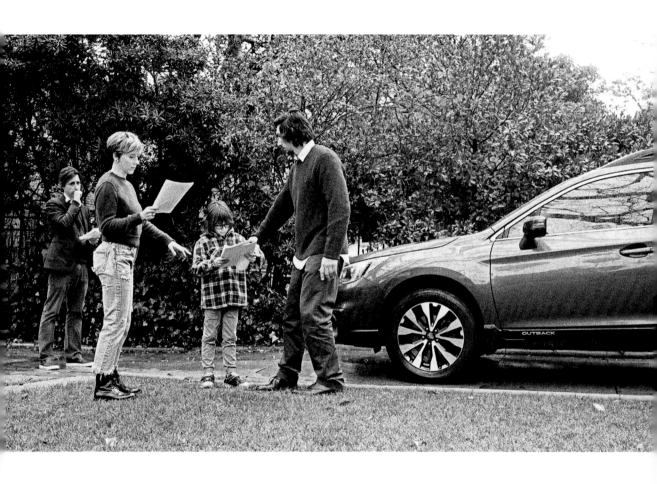

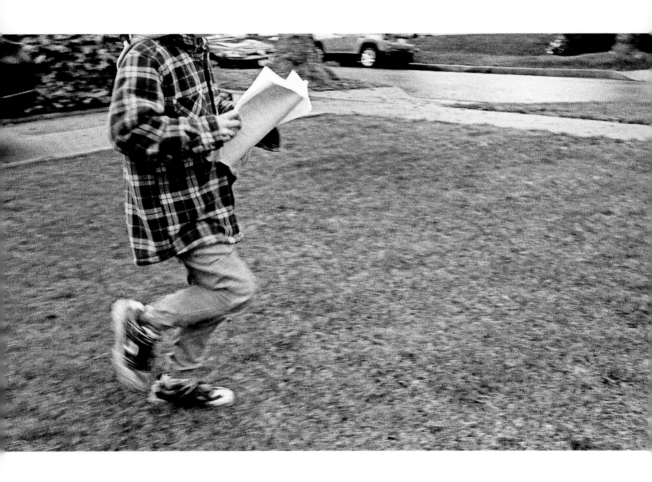

Charlie

sc. 47

airport / meets Bert

COSTUMES BY MARK BRIDGES

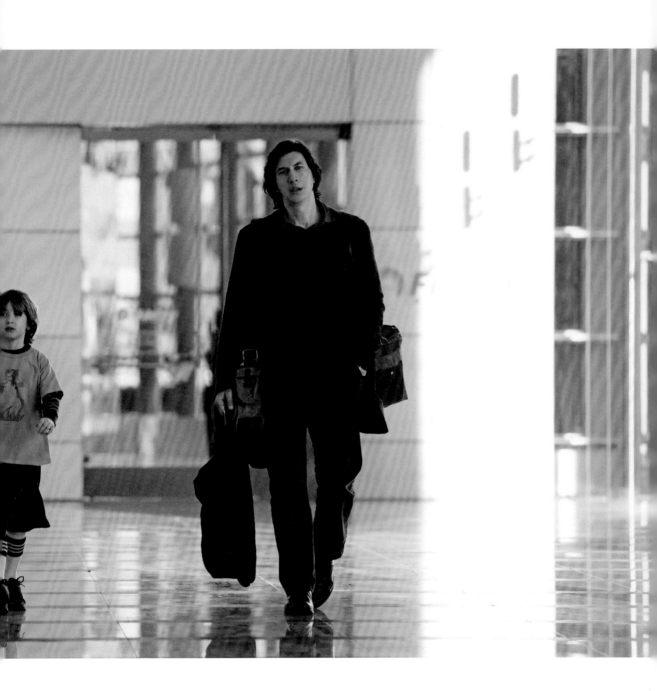

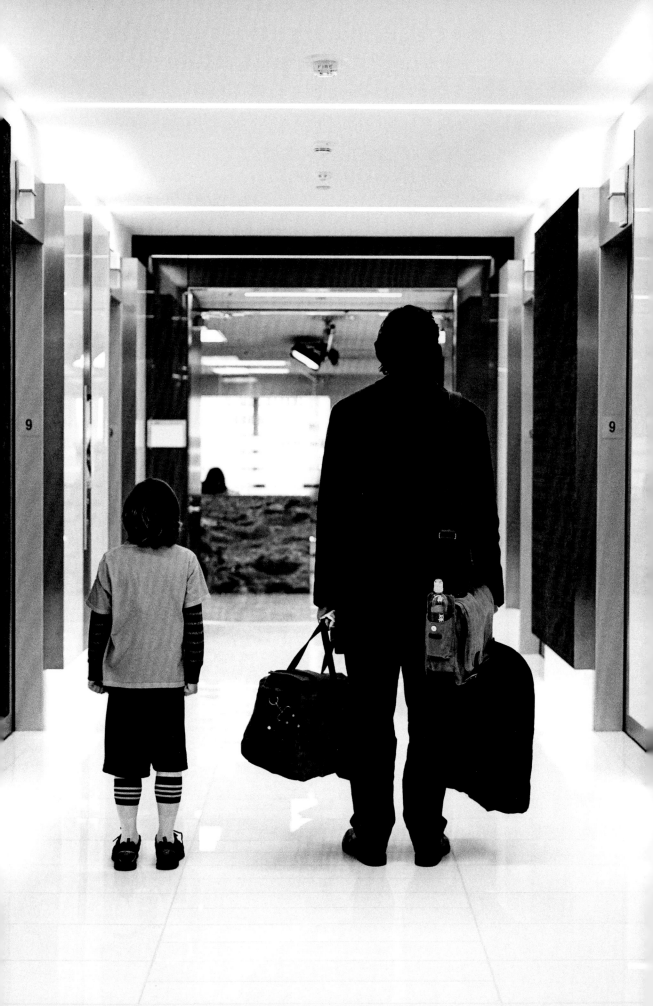

TED
We're going to have to reshape the narrative.

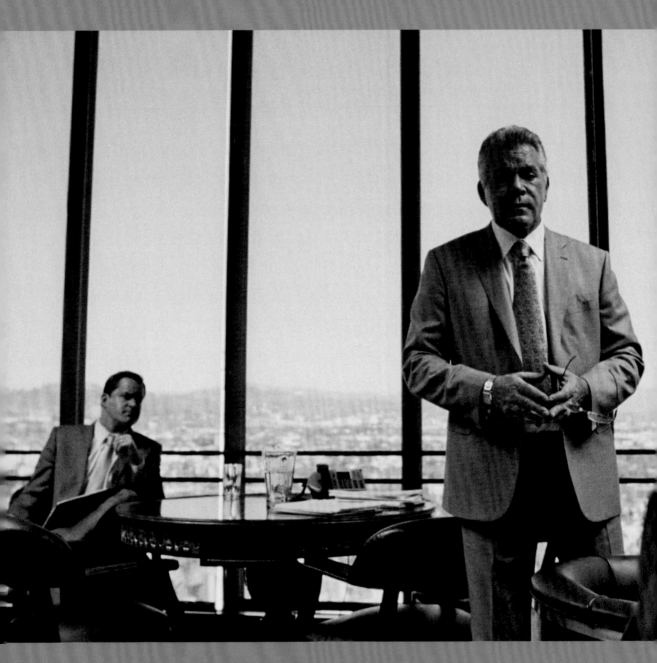

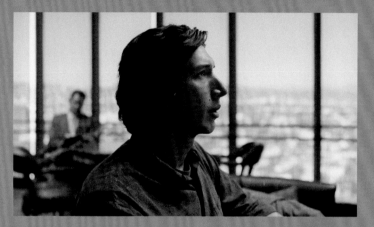

JAY MAROTTA
You'll end up hating me and Ted
before it's all over just because of
what we represent in your life.

CHARLIE
I'm sure you're right.

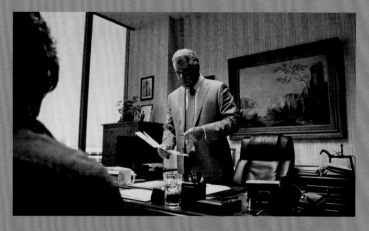

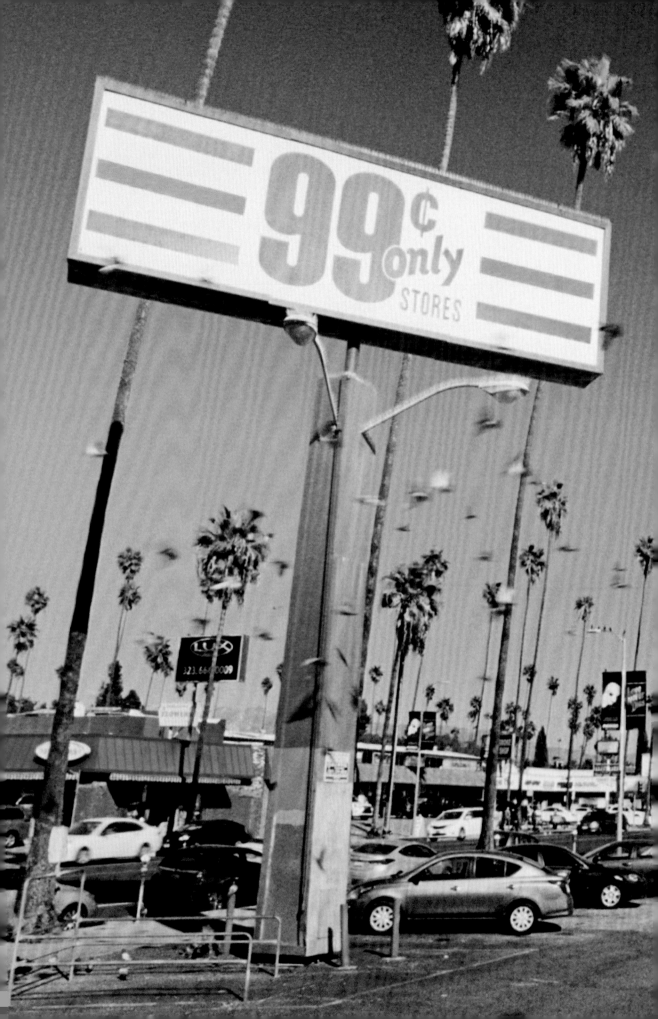

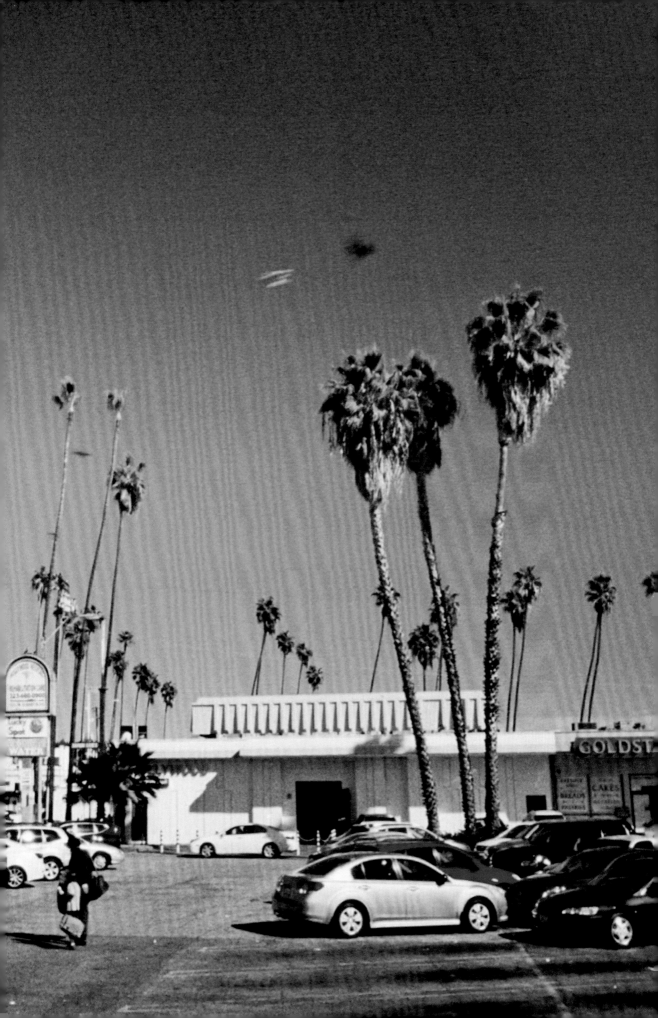

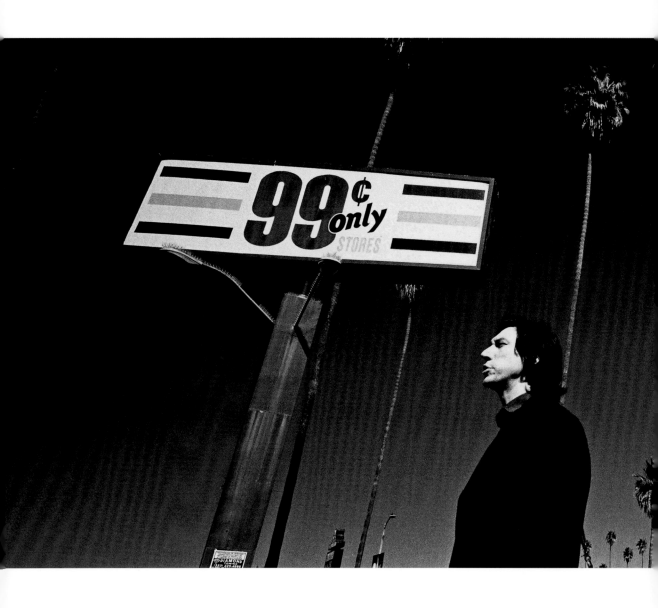

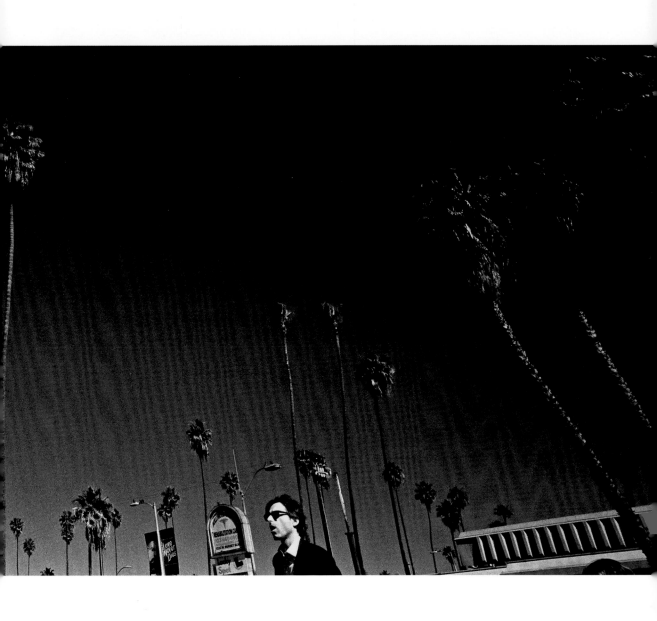

"People expect things from one another, and they're sometimes led to believe they're going to get what they expect. And I think that happens, for instance, between Bert and Charlie. I put on a good show of being a really sharp lawyer who's going to help him get what he deserves. He puts his trust in this character, this lawyer. In real life, you see people eventually for what they are and who they are. And there's a little bit of disillusionment that falls in there.

If you delineate the edges of that enough—not too much, just enough to sharpen it—you see how funny it is, but you also still feel how painful it is. Disillusionment is not fun, especially if your life is at stake. When everything is lost all around you, and you're saying, 'well, I expected something else here, what's going on?' That can be funny. Maybe it's funny as long as it's happening to somebody else. I think it was Mel Brooks who said, 'If somebody falls in the sewer hole, that's funny. If you fall in the sewer hole, that's tragedy.' That's the way life is. Life is absurd and hopeful at the same time."

ALAN ALDA

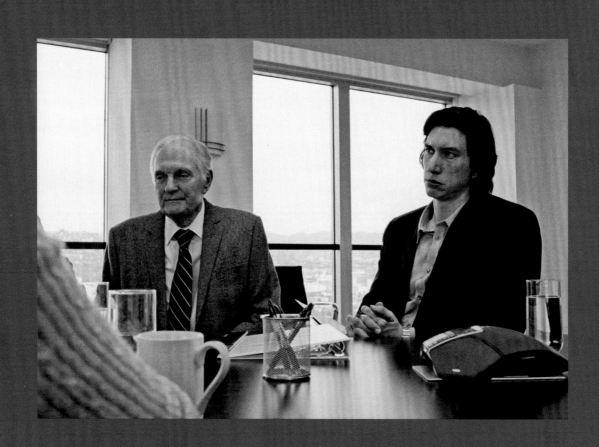

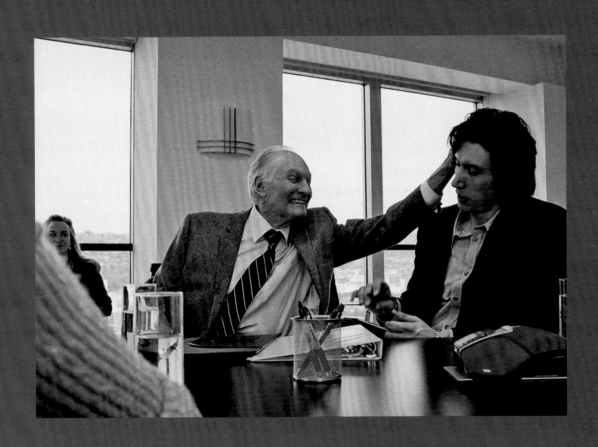

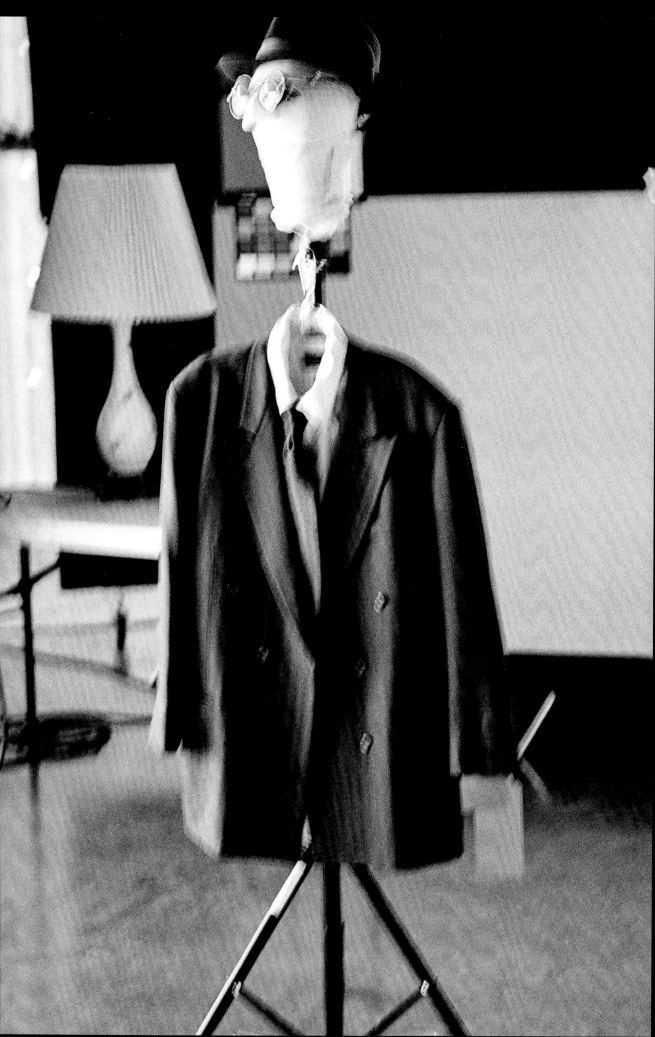

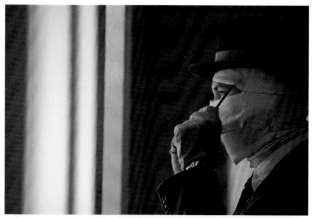

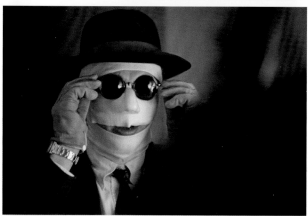

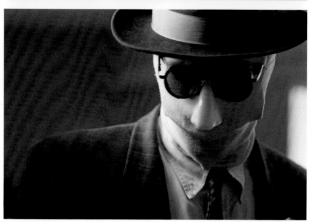

"**We just go around wearing these masks all the time.**"

JADE HEALY, PRODUCTION DESIGNER

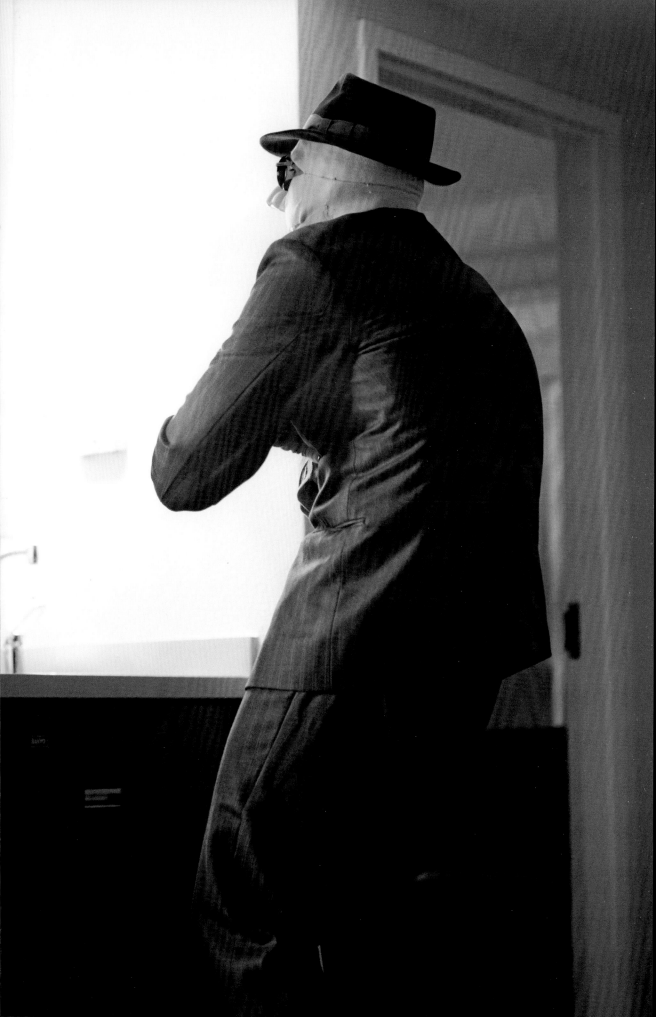

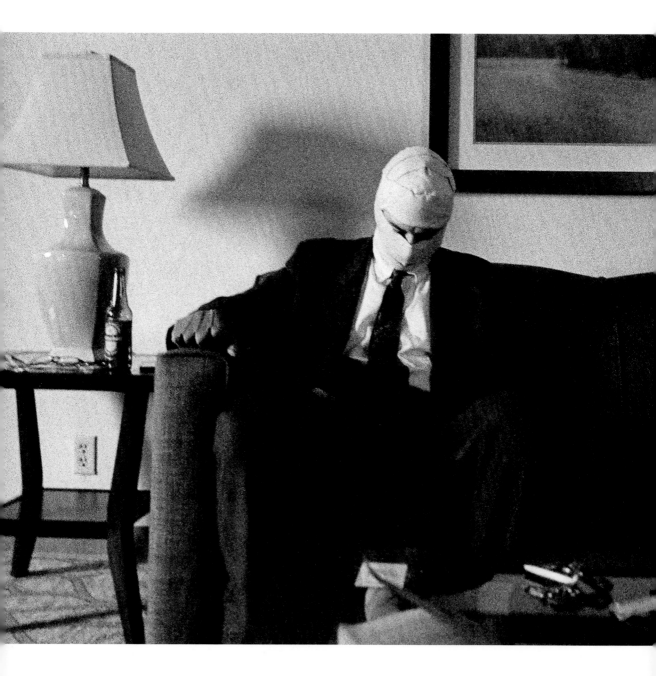

"One of the many sadnesses in a divorce is that you're not going to take the journey with this person you thought you were. Your plans for the rest of your life are permanently altered. For this reason, it was important to me that they be

relatively younger people, married for the first time. They've gone into this thing with the best of intentions—they're trying to do something big, which is what everybody does when they get married." NOAH BAUMBACH

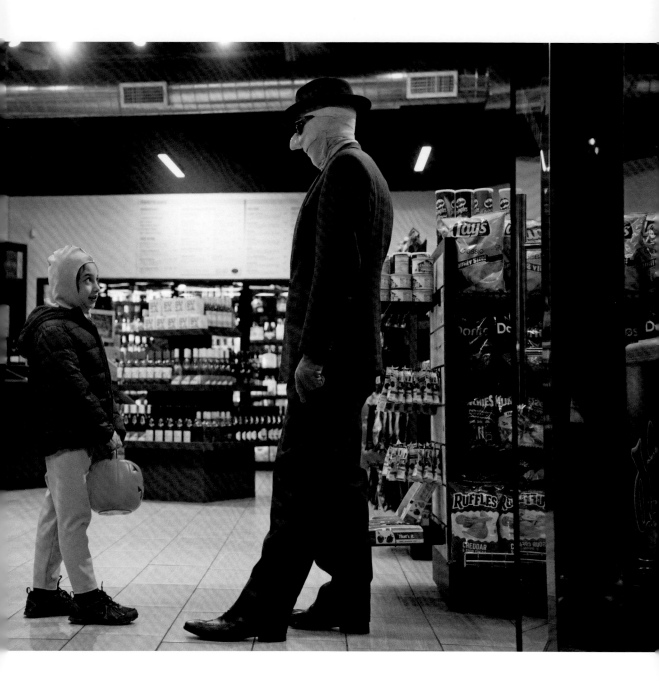

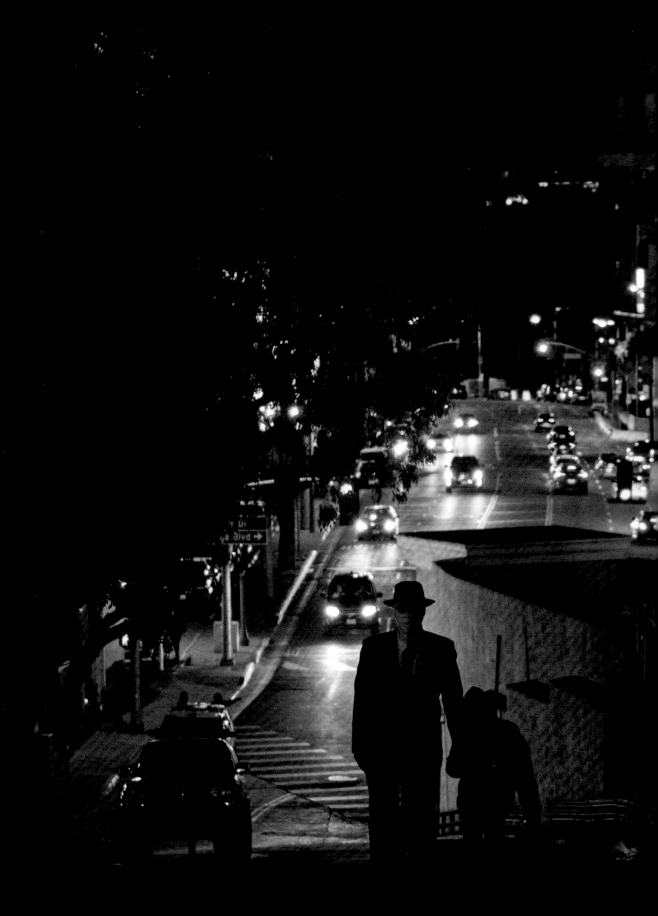

 HENRY
 But I like that we're sitting
 right now. I like to sit.

 CHARLIE
 That's true, Los Angeles does have
 sitting going for it.

 HENRY
 I think that's why I like Los
 Angeles better.

"We were very specific about where we put the camera in the car when it was Charlie and Henry. Because when you're driving a kid around, your view is of the road, and their view

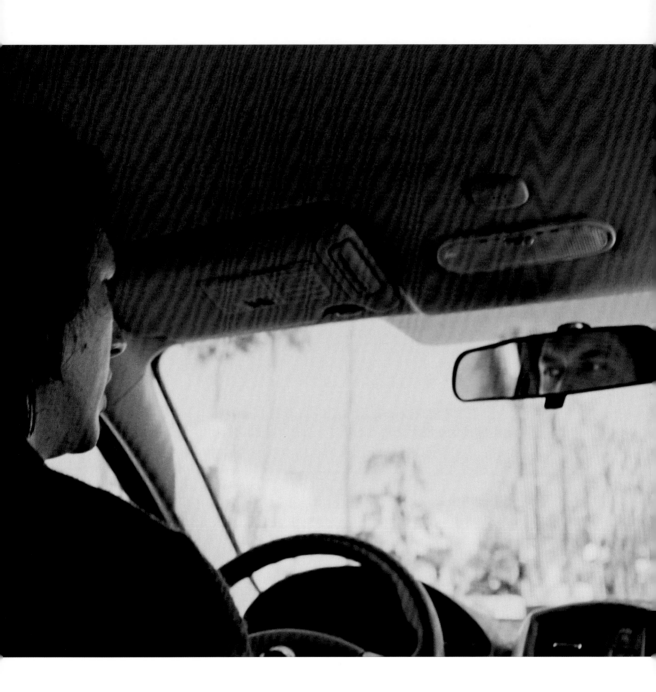

is of the back of your head. They're funny angles to have when you're talking to someone, because no one can really see the other's face." NOAH BAUMBACH

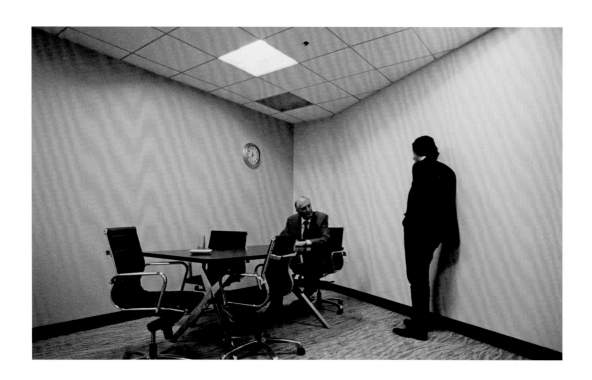

"Noah wanted a wide shot to show the imprisonment
of the room. And the rooms got smaller and smaller
as the journey went on for the characters."

ROBBIE RYAN, DIRECTOR OF PHOTOGRAPHY

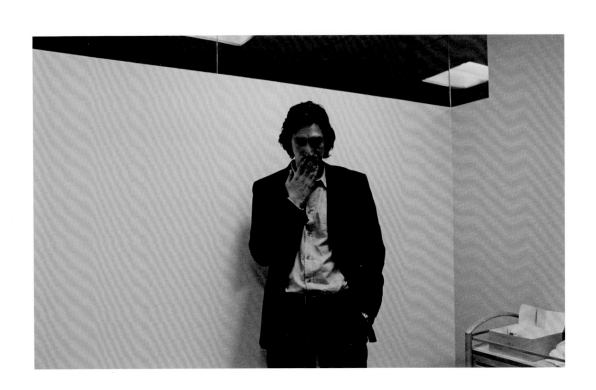

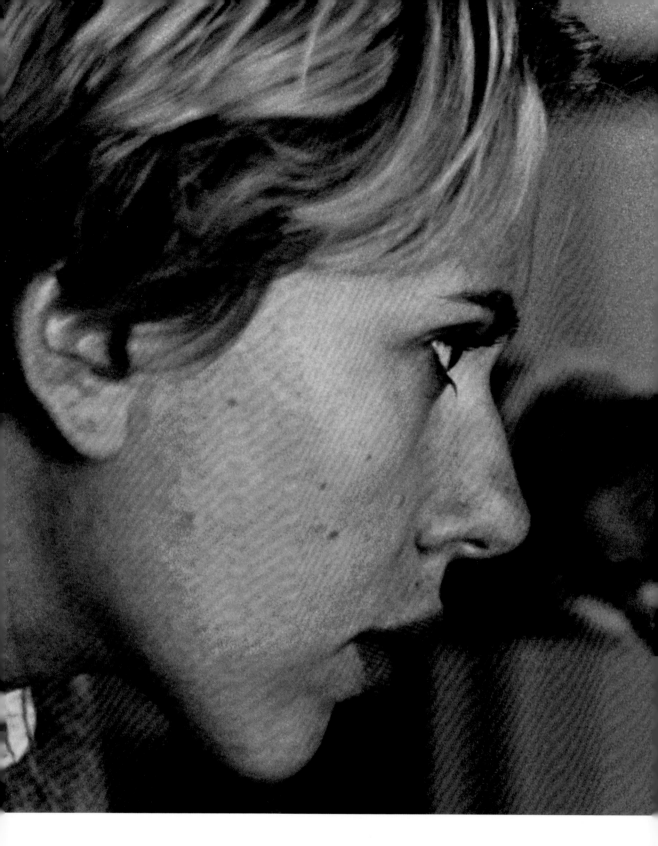

"Every character is so richly drawn, full and specific. You feel for them. They're all trying to rise above their damage."

JULIE HAGERTY

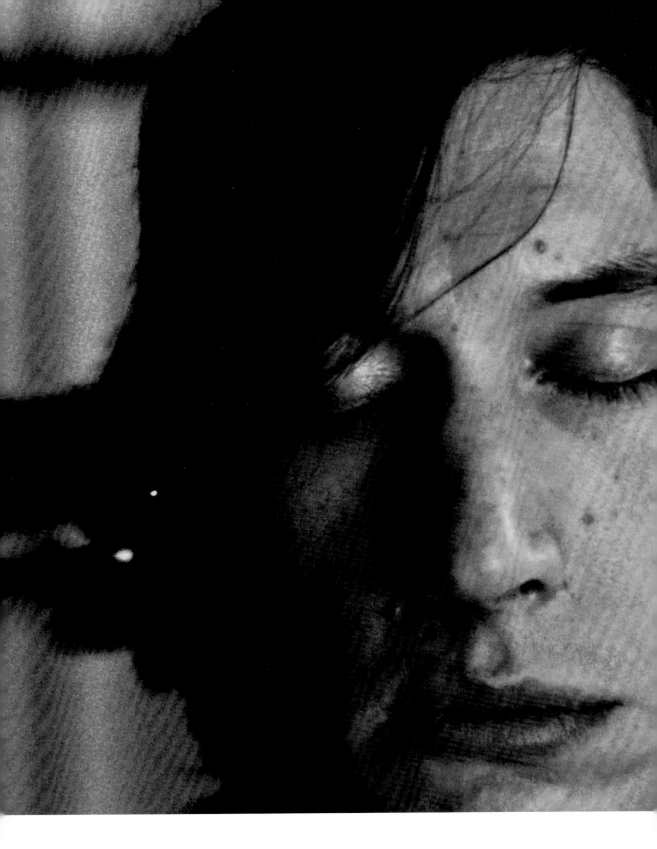

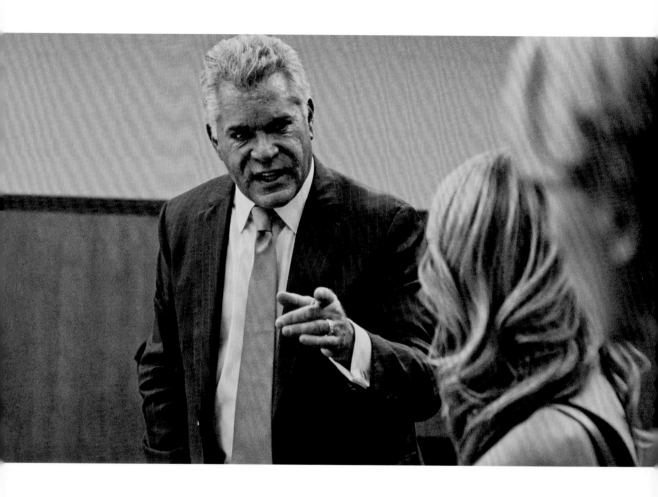

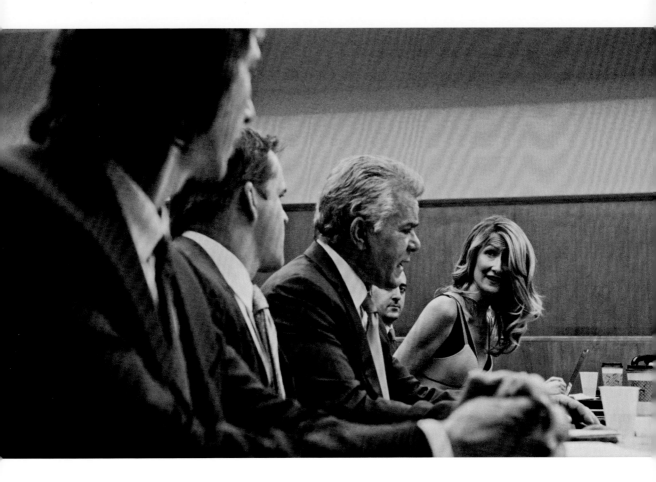

"Robbie and Noah wanted to show how it feels to be in a courtroom, and not how you see most courtrooms in movies. They wanted to shoot it down the table, because that's how it feels when you're sitting there."

JENNIFER LAME, EDITOR

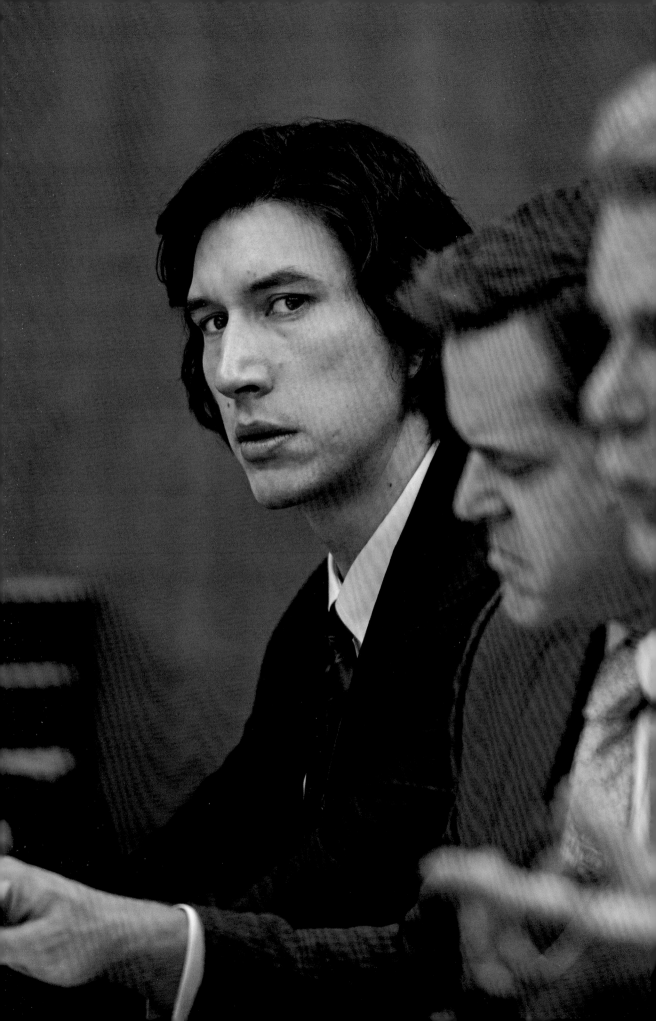

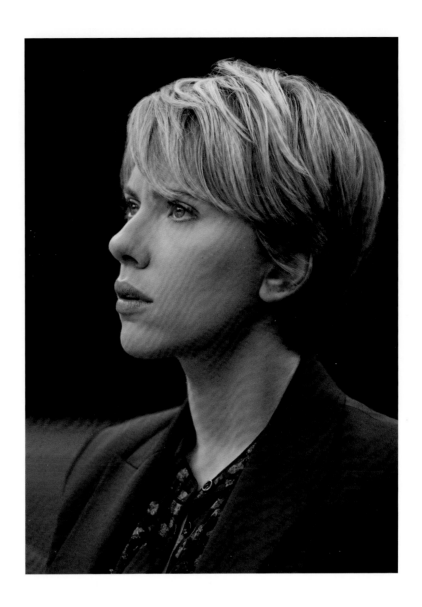

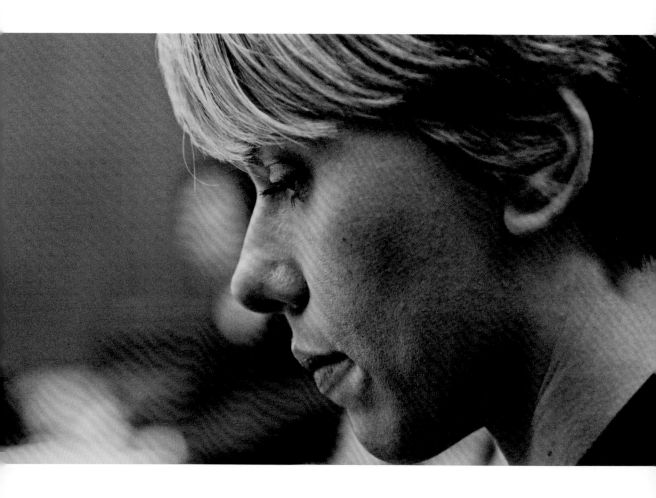

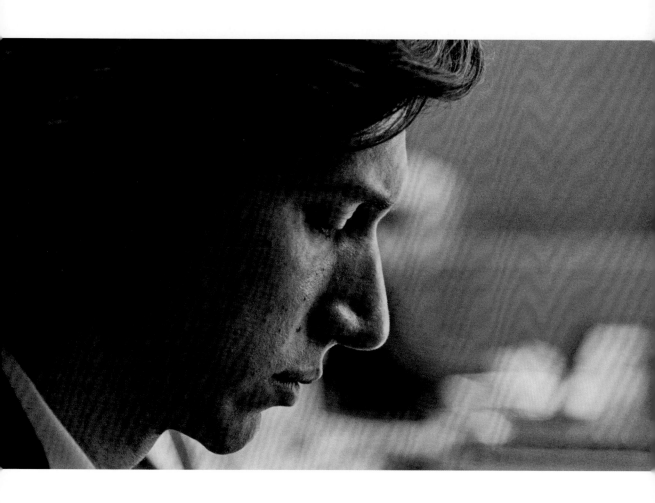

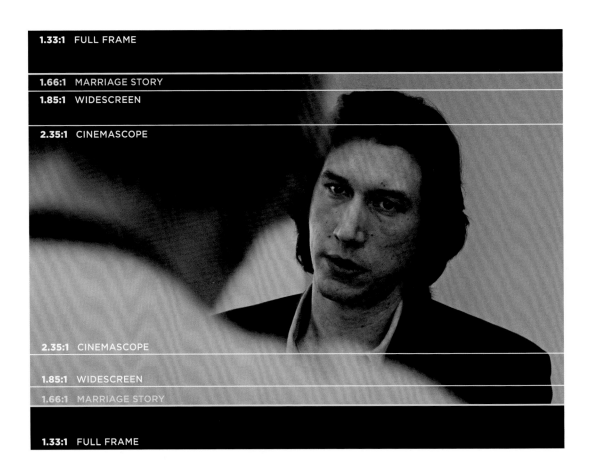

1.33:1 FULL FRAME

1.66:1 MARRIAGE STORY

1.85:1 WIDESCREEN

2.35:1 CINEMASCOPE

2.35:1 CINEMASCOPE

1.85:1 WIDESCREEN

1.66:1 MARRIAGE STORY

1.33:1 FULL FRAME

"I'm a fan of 1.66:1. It's very cinematic, but what Noah really likes is portraiture, and I find that 1.66:1 really accentuates the portraiture."

ROBBIE RYAN, DIRECTOR OF PHOTOGRAPHY

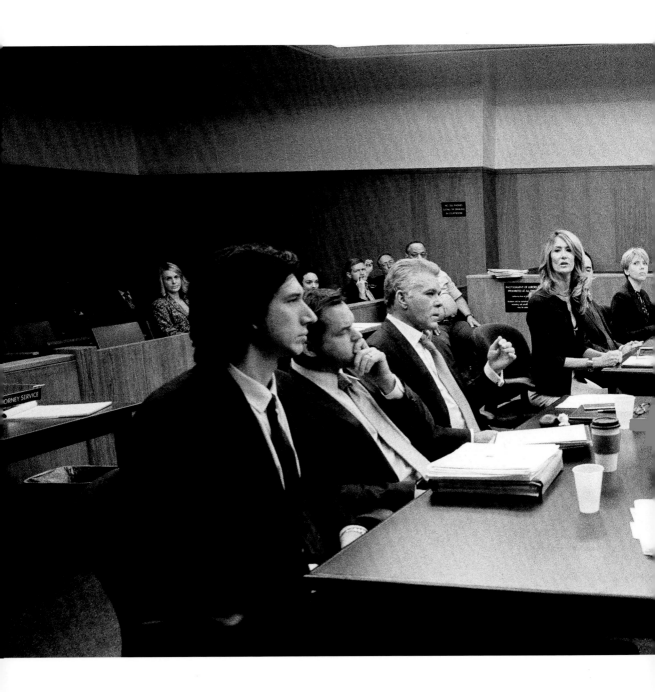

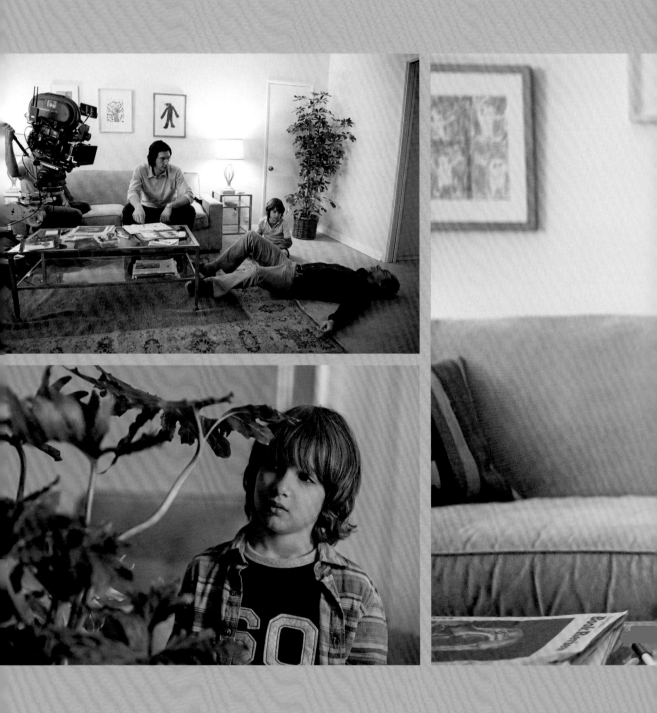

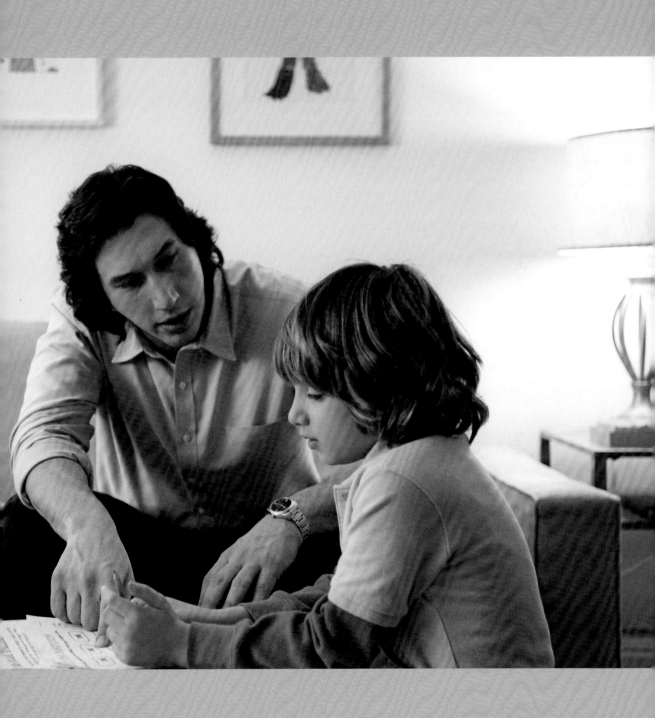

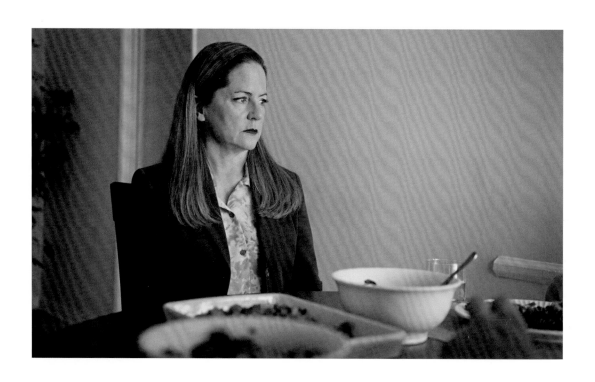

CHARLIE
Do you ever observe married people?

EVALUATOR
No, why would I?

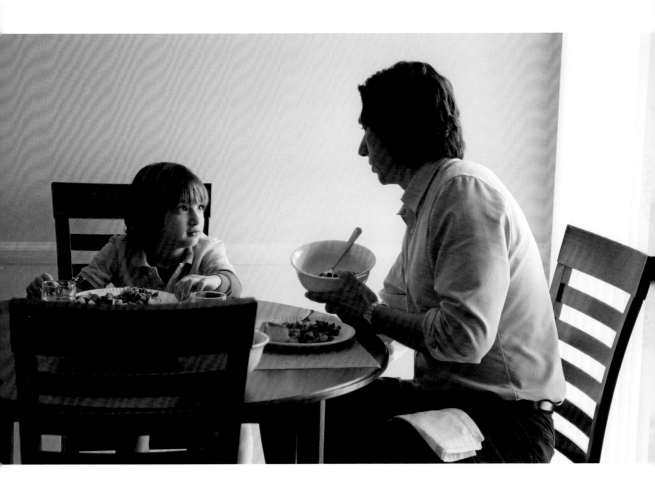

"That line I had in my head early on. It's only because these well-meaning but imperfect people have decided to break up that they come under such scrutiny. And it seems so absurd." NOAH BAUMBACH

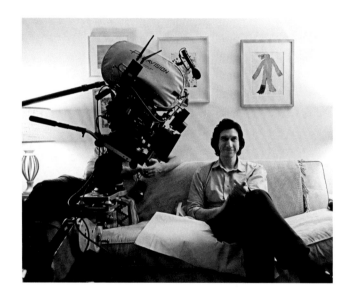

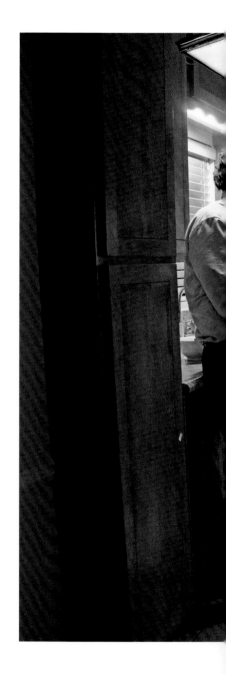

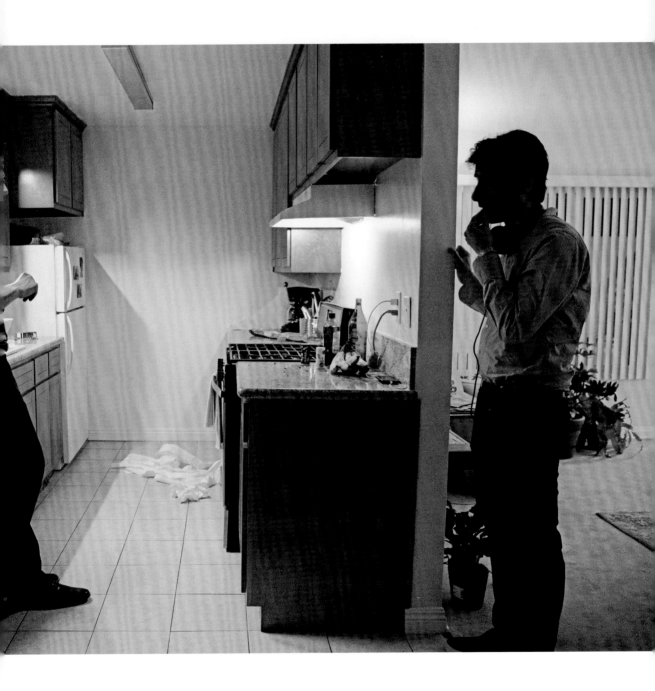

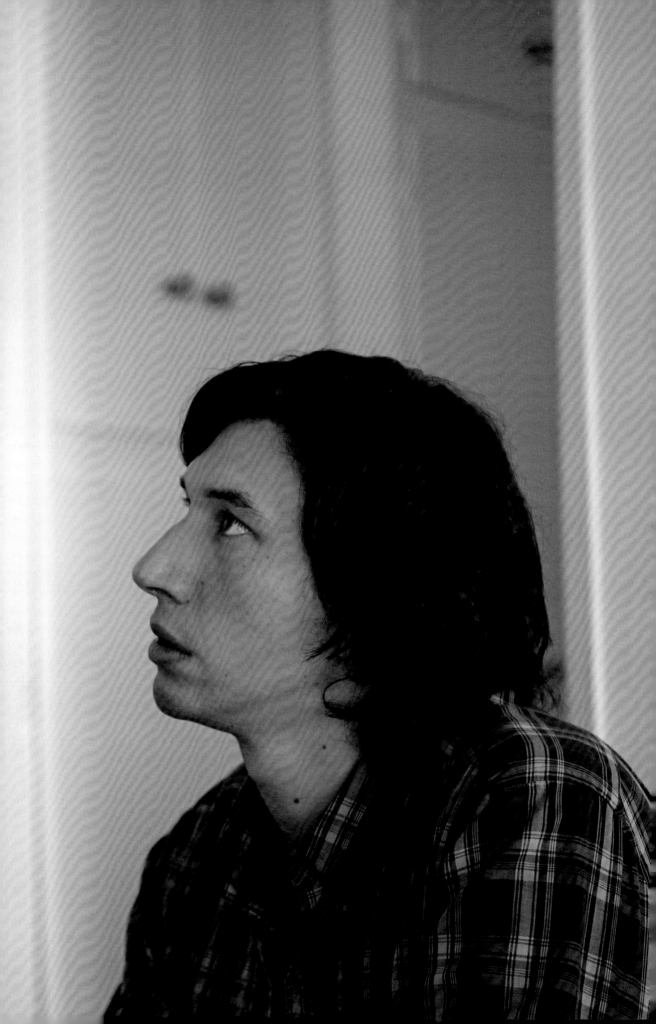

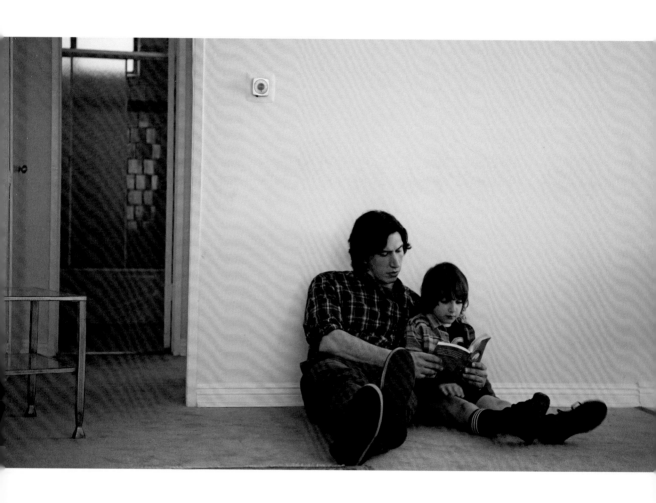

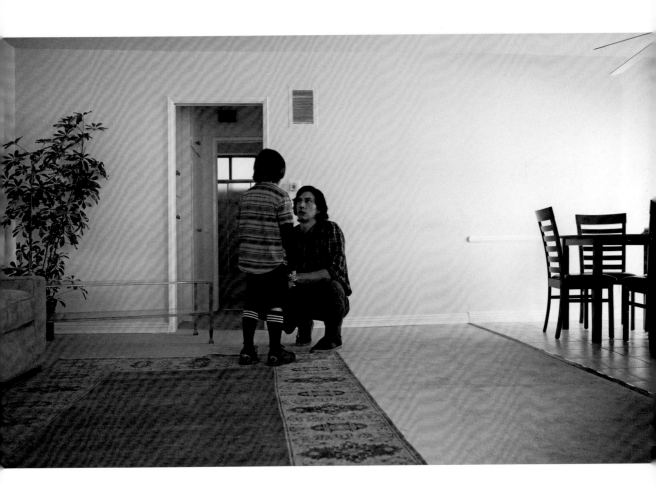

BERT
No matter what happens here, it's temporary.
He's growing up, he's going to have opinions
on the subject.

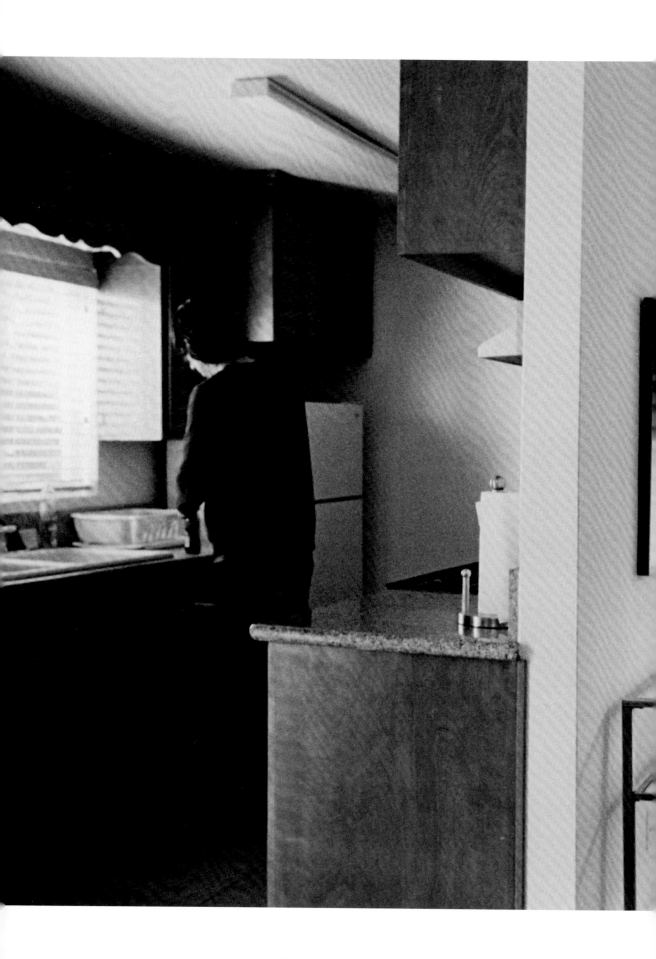

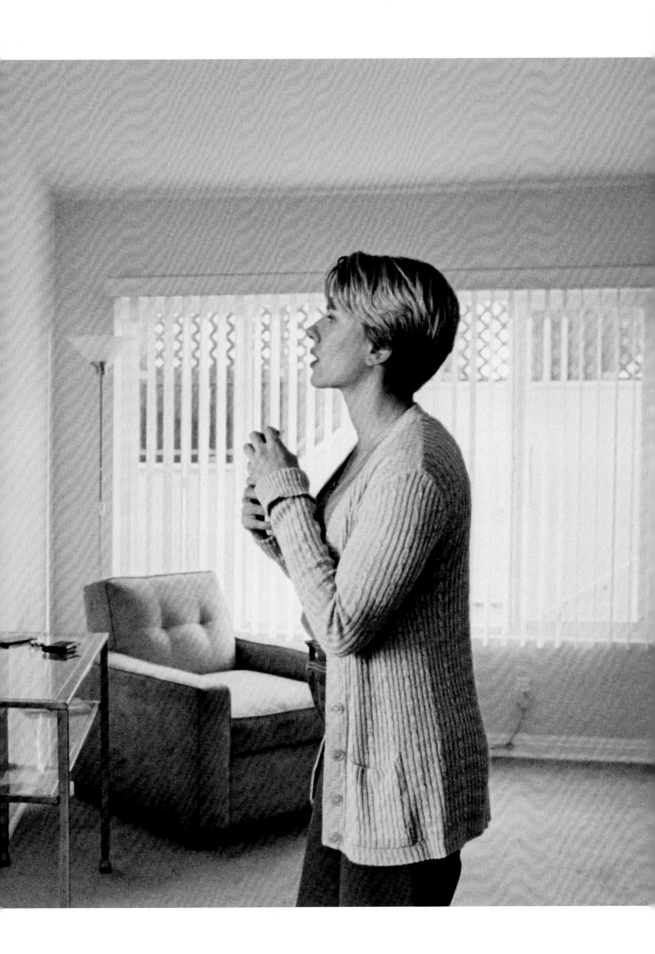

NICOLE
So... I thought we should
talk.

CHARLIE
Uh huh.

NICOLE
I feel like maybe things have
gone too far.

CHARLIE
Uh huh.

NICOLE
I mean, my mom has taken out
a loan against the house to
help me pay Nora--

CHARLIE
I thought I pay Nora.

NICOLE
You pay thirty percent of
Nora.

CHARLIE
Well, I'm going broke too
if that's any help. I've just
agreed to direct two shitty
plays and we can forget
putting anything away for
Henry's college.

NICOLE
(trying not to take the
bait)
It's just that... up until now
we've been able to keep Henry
at least somewhat removed. And
this will change that.

CHARLIE
Uh huh.

NICOLE
And we have to protect him.

CHARLIE
I agree.

NICOLE
Nora says the evaluator will
come into our homes. She'll
interview Henry in addition
to us, our family, friends,
enemies... And then she'll
observe us with him, how we
are as parents.

CHARLIE
Sounds awful.

NICOLE
I know! I feel like if anyone
observed me on any given day
as a mom, I'd never get
custody.
(pause)
That was a joke.

CHARLIE
I know. I feel the same way.

NICOLE
(smiles)
Right. So, maybe we can figure
something out between us--

CHARLIE
You'll remember I said this
to you at the beginning.

NICOLE
I know you did, but these are
different circumstances--

CHARLIE
I was anticipating these
circumstances--

NICOLE
Mm hm. Anyway... Shall we try
this?

CHARLIE
(pause)
OK.

There's a long silence. They both
laugh.

CHARLIE
I don't know how to start...

NICOLE
Do you understand why I want
to stay in LA?

CHARLIE
No.

NICOLE
Well, that's not...
Charlie, that's not a useful
way for us to start--

CHARLIE
I don't understand it.

NICOLE
You don't remember promising
that we could do time out
here?

CHARLIE
We discussed things. We were
married, we said things.
We talked about moving to
Europe, about getting a
sideboard or what do you call
it, a credenza, to fill that
empty space behind the couch.
We never did any of it.

NICOLE
And you turned down that
residency at the Geffen that
would have brought us here
and--

CHARLIE
It wasn't something I wanted.
We had a great theater
company and a great life
where we were.

NICOLE
You call that a great life.

CHARLIE
You know what I mean.

NICOLE
Me discovering you're fucking
Mary Ann--

CHARLIE
Don't pretend you're not
capable of deception. You
left Ben for ME.

CHARLIE
I don't mean we had a great
marriage. I mean, life in
Brooklyn... Professionally.
I don't know. Honestly I
never considered anything
different.

NICOLE
Well, that's the problem
isn't it? I was your wife,
you should have considered my
happiness too.

CHARLIE
Come on! You WERE happy.
You've just decided you
weren't now--

NICOLE
(not taking the bait)
So, OK, let's... I work here
now. My family is here.

CHARLIE
And I agreed to put Henry in
school here because your show
went to series. I did that
KNOWING that when you were
done shooting, he would come
back to New York...

NICOLE
Honey, we never said that.
That might have been your
assumption, but we never
expressly said that...

CHARLIE
We did say it.

NICOLE
When did we say it?

CHARLIE
I don't know <u>when</u> we said it,
but we said it!

NICOLE
I thought--

CHARLIE
 (remembering something)
We said it that time on the
phone--

NICOLE
Let me finish. Honey--
 (hesitates, angry at
 herself)
Sorry, I keep saying THAT.
 (resumes)
I thought... that if Henry
was happy out here and my
show continued, that we might
do LA for a while.

CHARLIE
I was not privy to that
thought process.

NICOLE
The only reason we didn't
live here was because you
can't imagine desires other
than your own unless they're
forced on you.

CHARLIE
OK, you wish you hadn't
married me, you wish you'd
had a different life. But
this is what happened.

NICOLE
 (trying to stay calm)
So what do we do?

CHARLIE
I don't know.

NICOLE
Nora says there's no coming
back from this.

CHARLIE
Fuck Nora. I hate fucking
Nora telling me I always
lived in LA even though I
never lived in LA. How could
you have her say those things
about me?

NICOLE
Jay said them about me too!
 (hesitates)
You shouldn't have fired Bert.

CHARLIE
I needed my own asshole!

NICOLE
Let's both agree both of our
lawyers have said shitty
stuff about both of us--

CHARLIE
Nora was worse.

NICOLE
Jay called me an alcoholic!

CHARLIE
You pulled the rug out from
under me and you're putting
me through hell--

NICOLE
You put me through hell
DURING the marriage!

CHARLIE
Is that what that was? Hell?

NICOLE
And now you're going to put
Henry through this horrible
thing so you can yet again
get what you want.

CHARLIE
It's not what I want...
I mean, it's what I want, but
it's what was...WAS...what's
best for him.

NICOLE
I was wondering when you'd
get around to Henry and what
HE actually wants.

CHARLIE
Oh, fuck off--

NICOLE
No, YOU fuck off. If you
listened to your son, or
anyone, he'd tell you he'd
rather live here.

CHARLIE
Stop putting your feelings
about me onto Henry.

NICOLE
He tells me he likes it here
better.

CHARLIE
He tells you because he knows
it's what you want to HEAR!

NICOLE
He tells me you're on the
phone all the time. You don't
even play with him.

CHARLIE
Because I'm going through a
divorce in LA and trying to
direct a play in New York.

NICOLE
You're fighting for something
you don't even WANT.

CHARLIE
Which closed because I wasn't
THERE! That was a HUGE
opportunity for me. For the
theater. And I let everyone
down.

NICOLE
You're being so much like
your father.

CHARLIE
DO NOT compare me to my father.

NICOLE
I didn't compare you. I said
you were acting like him.

CHARLIE
You're exactly like your mother!
Everything you complain about
her, you're doing. You're
suffocating Henry.

NICOLE
First of all, I love my mother,
she was a great mother!

CHARLIE
I'm just repeating what
you've told me--

NICOLE
Secondly, how dare you
compare my mothering to my
mother? I might be like my
father, but I'm NOT like my
mother.

CHARLIE
You ARE! And you're like my
father. You're also like MY
mother. You're all the bad
things about all of these
people. But mostly your
mother. When we would lie in
bed together, sometimes I
would look at you and see HER
and just feel so GROSS.

NICOLE
I felt repulsed when you
touched me.

CHARLIE
You're a slob. I made all
the beds, closed all the
cabinets, picked up after
you like an infant--

NICOLE
The thought of having sex
with you makes me want to
peel my skin off.

CHARLIE
You'll never be happy. In
LA or anywhere. You'll
think you found some better,
opposite guy than me and
in a few years you'll rebel
against him because you need
to have your VOICE. But you
don't WANT a voice. You just
want to fucking complain
about not having a VOICE.

NICOLE
I think of being married
to you and that woman is a
stranger to me.

CHARLIE
You've regressed. You've gone
back to your life before you
met me. It's pathetic.

NICOLE
We had a child's marriage.

People used to say to me
that you were too selfish
to be a great artist. I used
to defend you. But they're
absolutely right.

CHARLIE
All your best acting is
behind you. You're back to
being a HACK.

NICOLE
You gaslighted me. You're a
fucking villain.

CHARLIE
You want to present yourself
as a victim because it's a
good legal strategy, FINE.
But you and I both know you
CHOSE this life. You wanted
it until you didn't.

Nicole is silent.

CHARLIE
You USED me so you could get
out of LA.

NICOLE
I didn't use you--

CHARLIE
You did and then you BLAMED
me for it. You always made
me aware of what I was doing
wrong, how I was falling short.

Life with you was JOYLESS.

NICOLE
So you had to fuck someone
else? How could you?

CHARLIE
You shouldn't be upset that I
fucked her, you should be upset
that I had a laugh with her.

NICOLE
Do you love her?

CHARLIE
No! But she didn't hate me.
You hated me.

NICOLE
You hated ME. You fucked
someone we worked with.

CHARLIE
You stopped having sex with
me in the last year. I never
cheated on you.

NICOLE
That was cheating on me.

CHARLIE
But there's so much I could
have done. I was a director
in my 20s who came from
nothing and was suddenly on
the cover of fucking Time Out

New York. I was hot shit--and
I wanted to fuck EVERYBODY
and I didn't. And I loved
you and didn't want to lose
you... and I'm in my twenties
and I didn't want to lose
that too. And you wanted SO
much so fast... I didn't even
want to get married... and
fuck it, there's so much I
DIDN'T do.

 NICOLE
Well, thanks for that.

 CHARLIE
You're welcome. You're...
welcome.

Nicole stamps her feet and shakes
her fists like a child having a
tantrum.

 NICOLE
I can't believe I have to
know you FOREVER!

 CHARLIE
You're fucking insane!

Charlie raises his arm and punches
the wall. The cheap drywall cracks
and chips.

 CHARLIE
And you're fucking <u>winning</u>.

 NICOLE
Are you kidding? I wanted to
be married. I'd ALREADY LOST.
 (sadly)
You didn't love me as much
as I loved you.

 CHARLIE
 (pause)
What does that have to do
with LA?

Nicole stares at him, incredulous.

 CHARLIE
What?

 NICOLE
You're so merged with your
own selfishness that you
don't even identify it as
selfishness anymore. YOU'RE
SUCH A DICK.

 CHARLIE
Every day I wake up and hope
you're dead-- Dead like--

And then Charlie starts crying.

 CHARLIE
 (through tears)
If I could guarantee Henry
would be OK, I'd hope you get
an illness and then get hit
by a car and DIE.

He sinks down, weeping. All this
vitriol has taken its toll. Nicole
watches, taken aback. She walks
over and gently puts her hand on
his shoulder. He shakes and cries.

 NICOLE
I know.

Finally, he looks up at her.

 CHARLIE
I'm sorry.

 NICOLE
Me too.

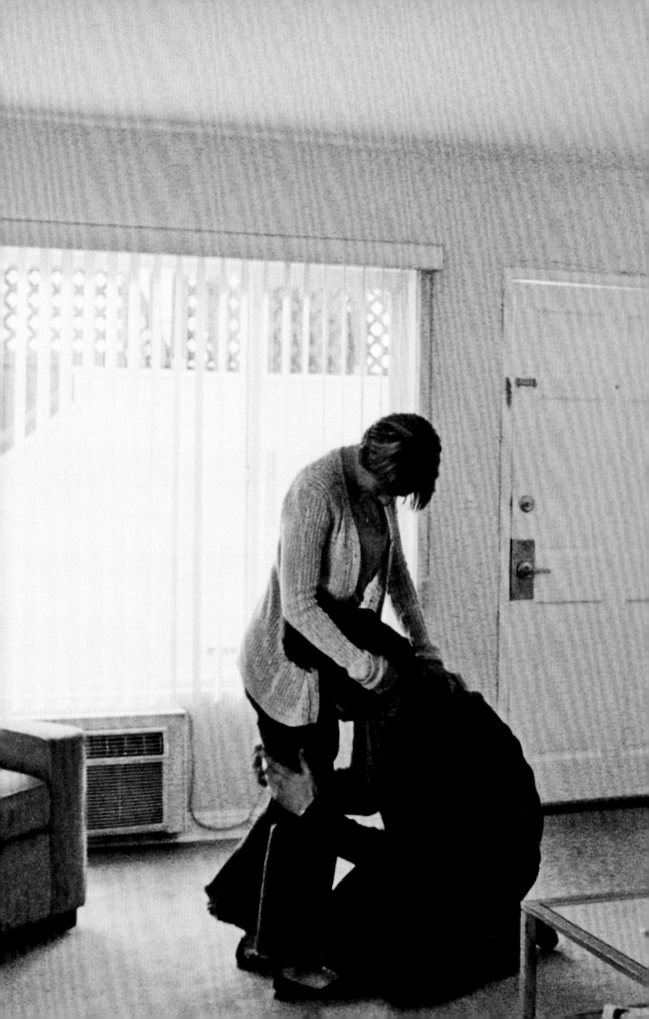

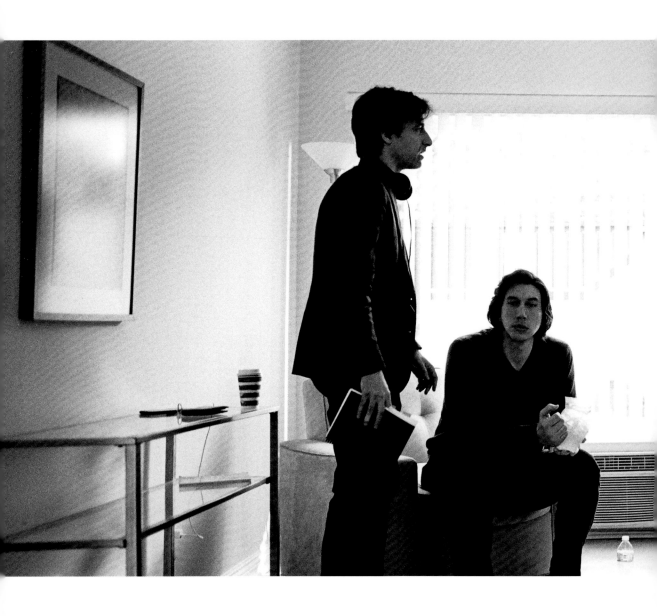

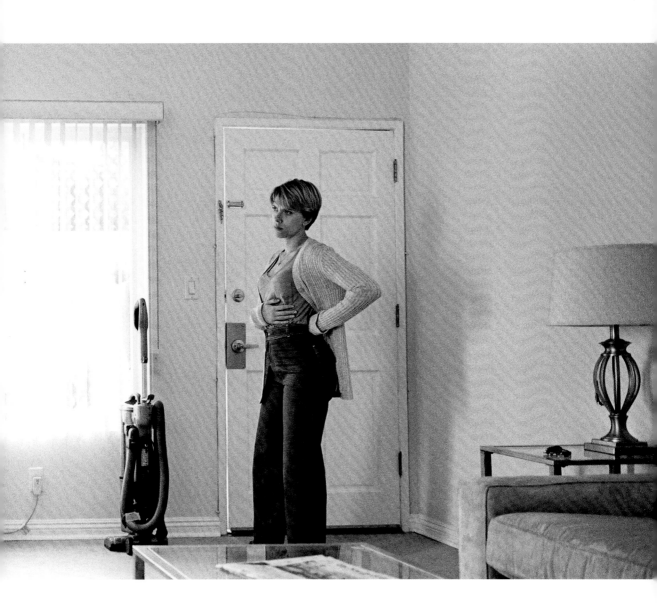

"We're trying to get to the truth of something.
That's where our relationship exists."

SCARLETT JOHANSSON

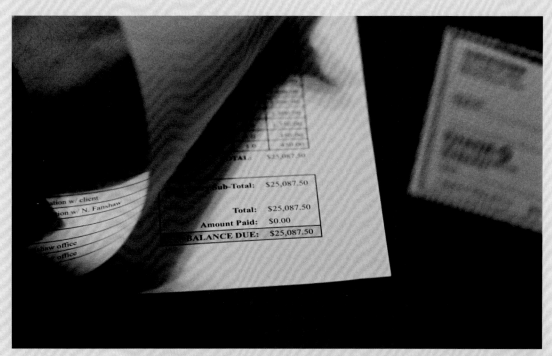

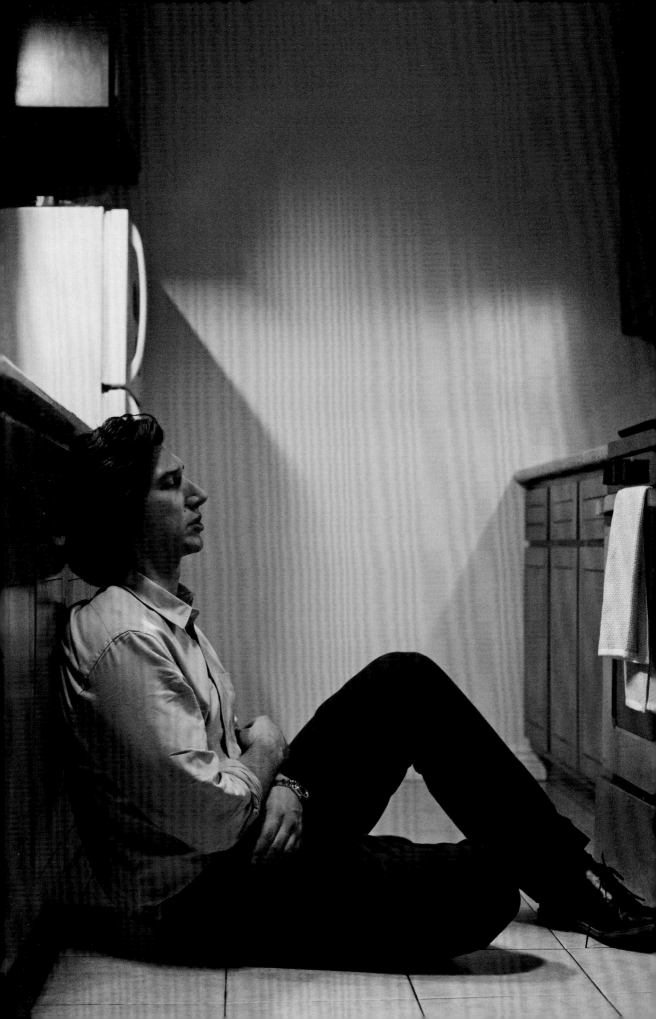

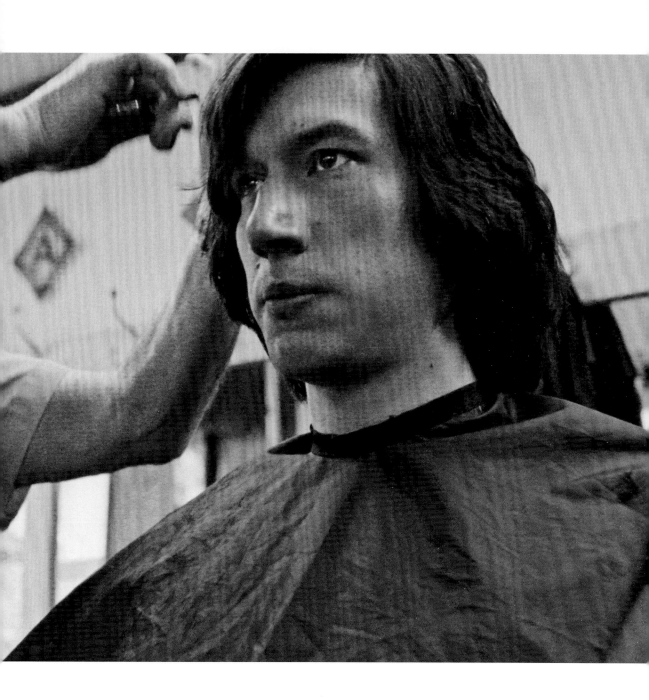

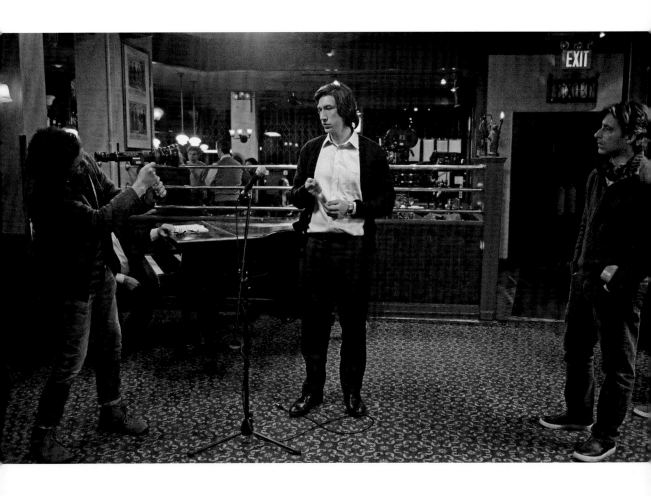

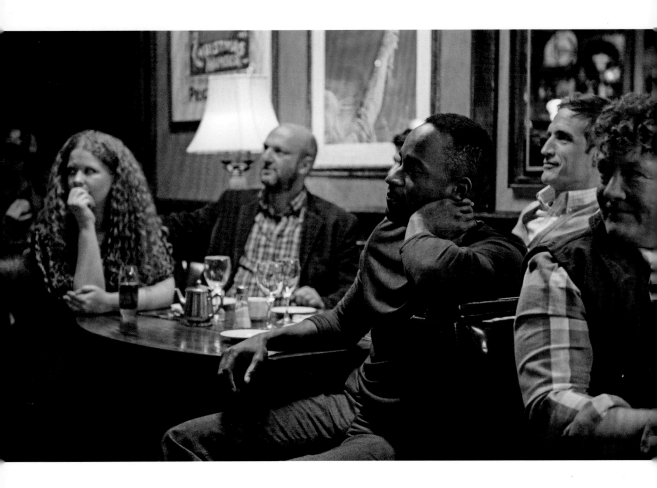

"Adam is the best collaborator you could hope for—there's always something in him pushing, looking for another thing. He might alter the rhythm of a line or change his physicality all in search of a truer moment. And once he's arrived there, he can live in that space for a while, take further direction, refine it. It's conscious and unconscious simultaneously. It's my favorite way to work." NOAH BAUMBACH

He gets up and walks to the piano.

People know who he is, and are
intrigued to see what he's
going to do.

Sings "Being Alive" from Company.
It's sloppy, but surprisingly
emotional and comes from a deep
place. And in the end is beautiful.

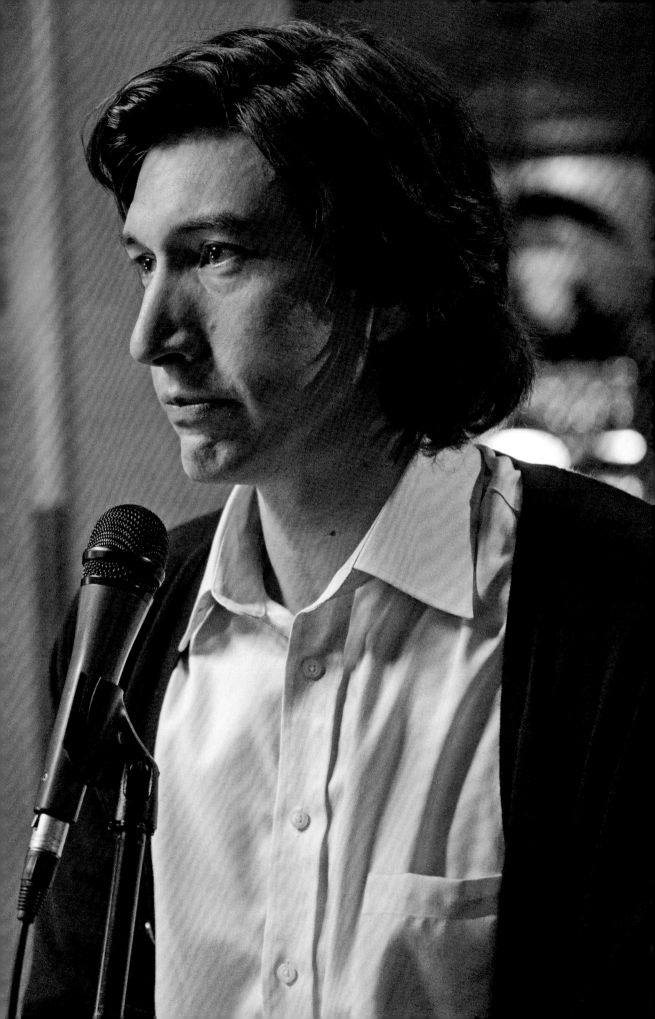

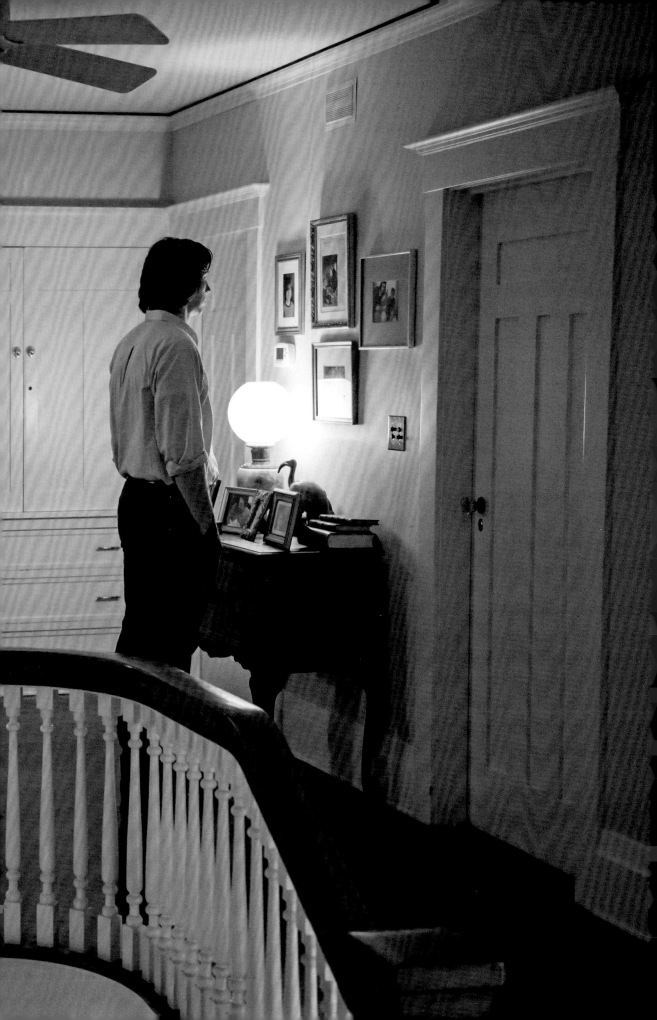

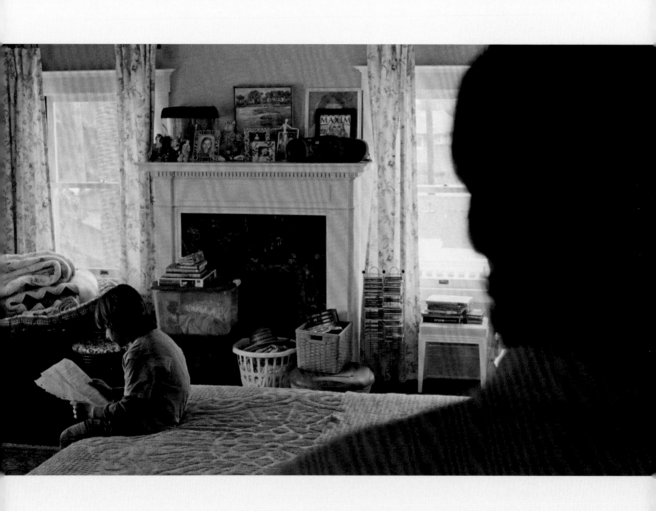

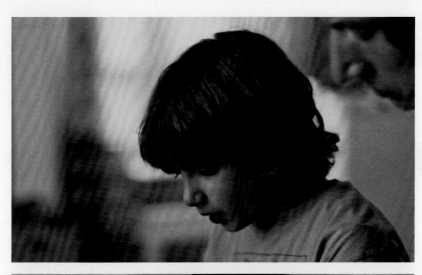
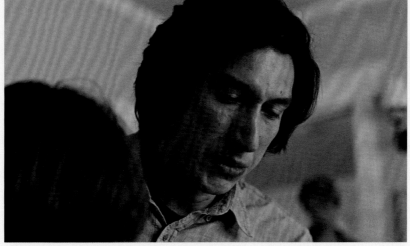

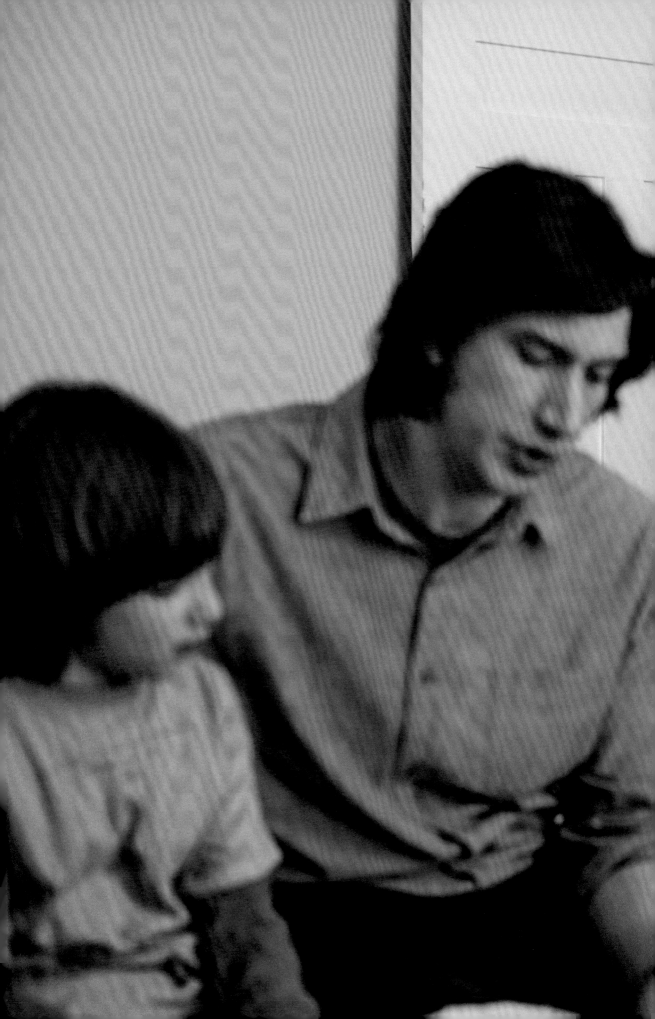

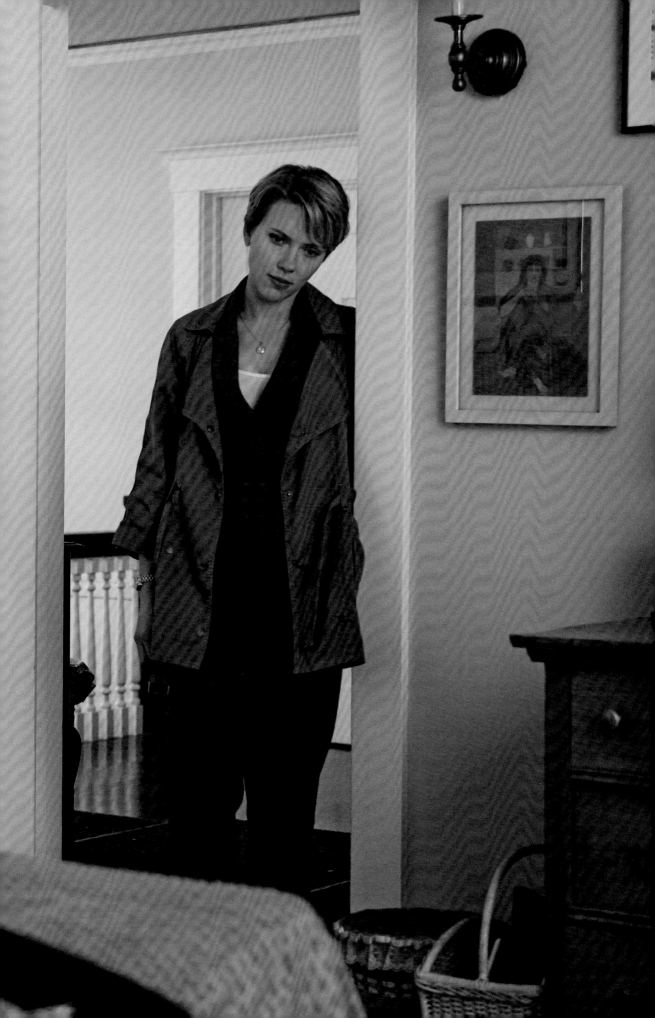

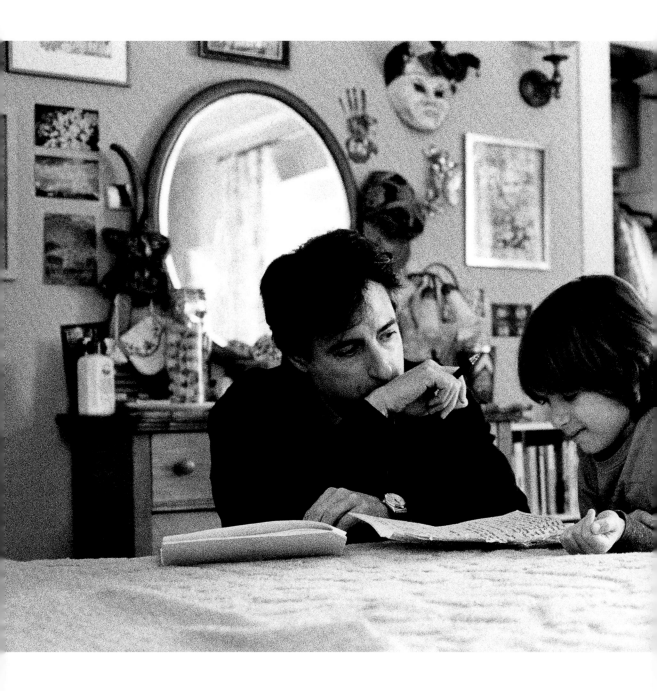

"For Henry, the confusion, the pain of what's going on is essentially indirect because of his age. It's very moving to me how kids tend to deal with difficult situations when they don't have the language for it yet." NOAH BAUMBACH

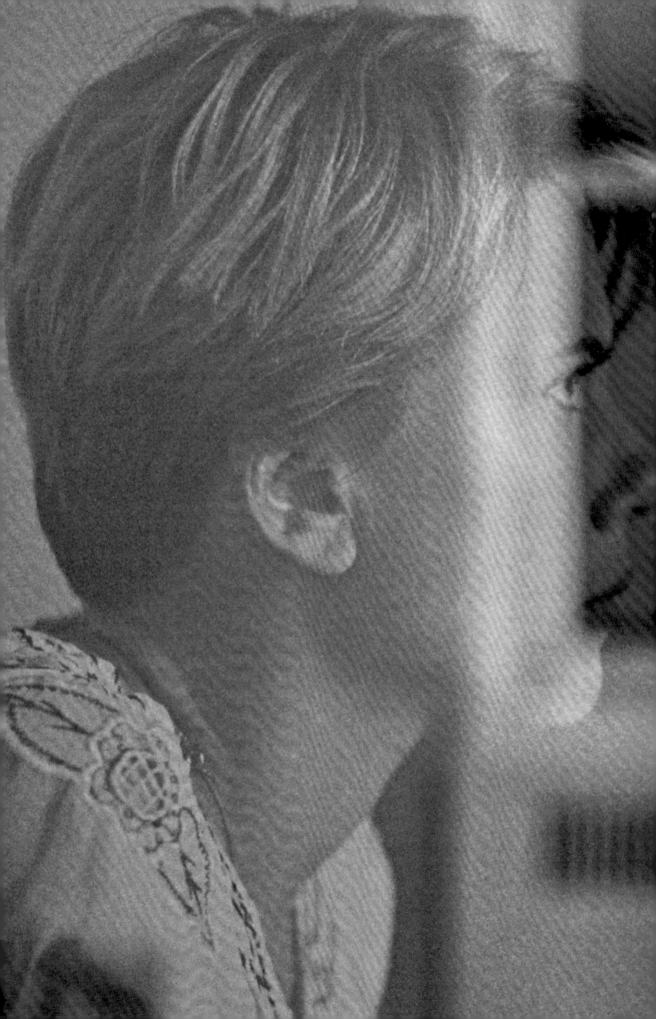

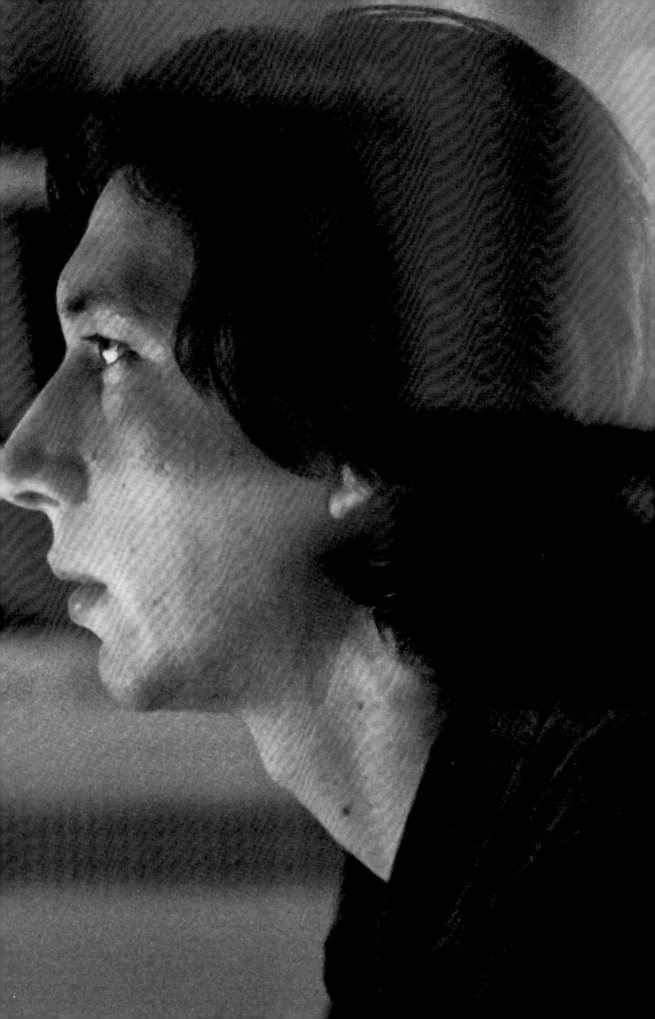

Henry, Nicole, Carter,
Sandra are dressed as
the Beatles from Sgt.
Pepper. Carter is Paul.
Henry is Ringo. Nicole is
John. Sandra is George.
Charlie's a ghost.

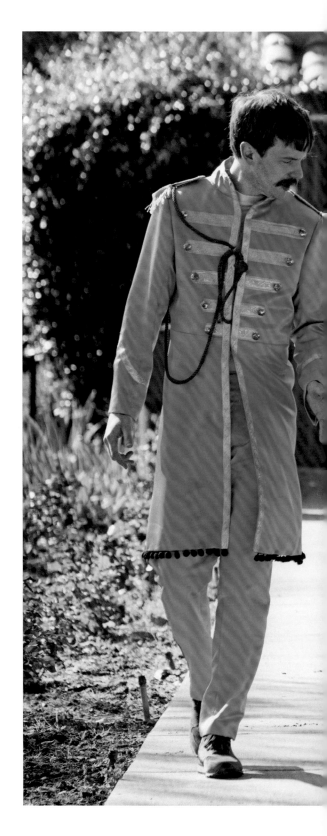

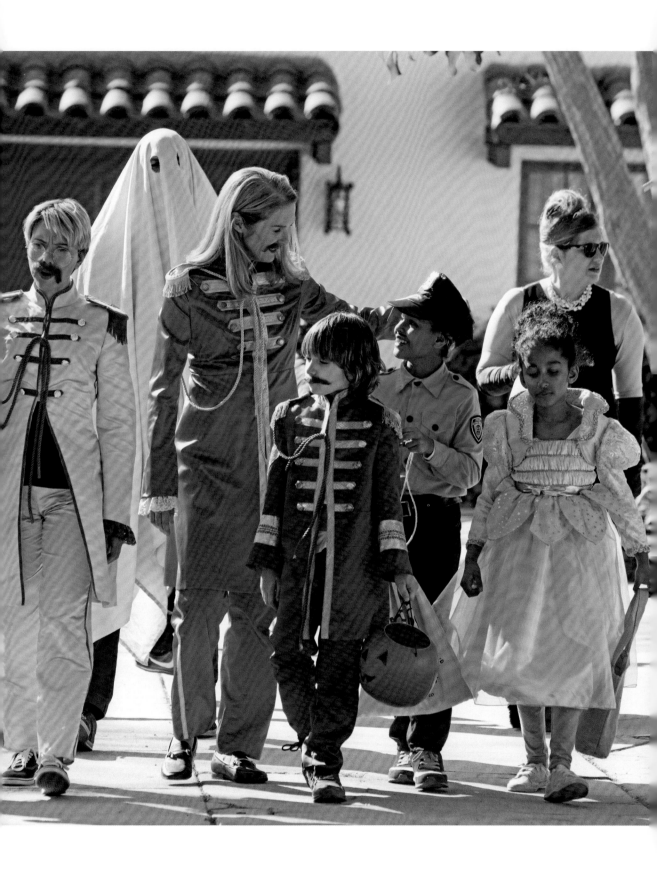

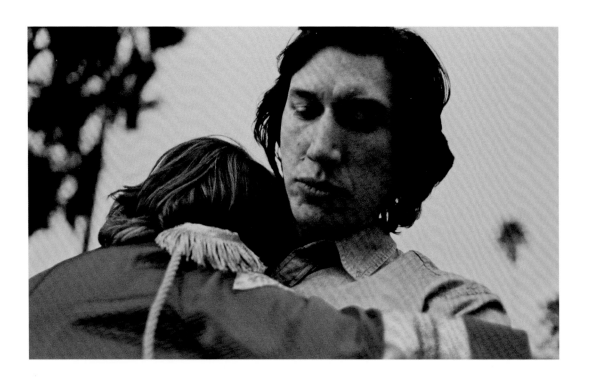

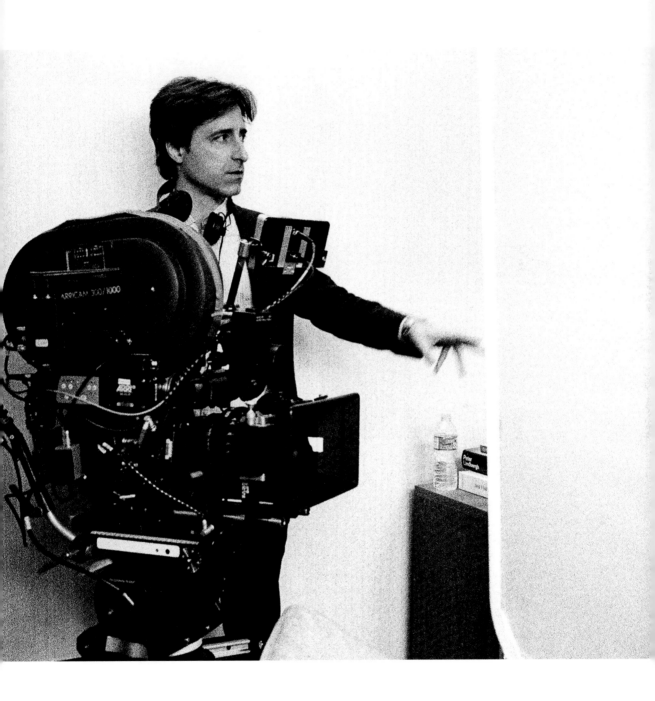

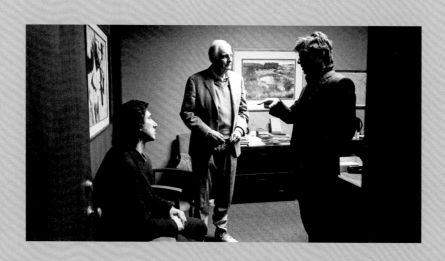

This book was printed in Italy by Grafiche Milani, designed using Atlas Typewriter and Gotham typefaces.

The photos were taken by Wilson R. Webb. Procured with various Nikon digital bodies, the wonderful Hasselblad Xpan and a trusty Mamiya 7ii.

Interviews by Kristopher Tapley & Eliel Ford.

© Netflix. 2019
© 2019 Assouline Publishing
3 Park Avenue, 27th floor
New York, NY 10016, USA
Tel: 212 989 6769 Fax: 212 647 0005
www.assouline.com

ISBN: 9781614289043
Printed in Italy by Grafiche Milani

Editorial Direction: Esther Kremer
Art Direction: Jihyun Kim
Designers: Mary Hachey and Sara de Lira
Editor: Brenna McDuffie
Photo Editor: Andrea Ramírez Reyes